CREATIVE COLOR

CREATIVE
COLOR

FABER BIRREN

West Chester, Pennsylvania 19380

Acknowledgments

The illustrations in this book are mainly the work of Armand Fiorenza. Original drawings have also been done by Vincent Gambello, Alex Sarkis and Bernard Symancyk.

New material copyright © 1987 by Faber Birren.
Library of Congress Catalog Number: 61-6947.
Original copyright ©1961 by Litton Educational Publishing, Inc.

Printed in the United States of America.
ISBN: 0-88740-096-5
Designed by Armand Fiorenza.
Published by Schiffer Publishing Ltd.
1469 Morstein Road, West Chester, Pennsylvania 19380

This book may be purchased from the publisher.
Please include $2.00 postage.
Try your bookstore first.

Contents

Foreword

Color is a progressive art. In painting, sculpture, literature, the drama, it is quite debatable if modern accomplishments surpass those of the past in quality of expression. The modern artist may be different; but is he superior?

Yet with color, there is a long history of achievement and increased knowledge. The physicist has exposed many of the mysteries of the nature and manifestations of light. The chemist has performed miracles in the making of dyestuffs and pigments. Most remarkable, scientists in the fields of psychology and physiological optics have probed the wonders of sensation and perception and given the world a revealing picture of the human nature of vision unrecognized in the past.

This book has been many years in the making. While it draws much from tradition, its chief effort has been to explore new realms of creation. Where the Impressionist of a past generation went to the physicist for new concepts in the manipulation of color, the modern approach has led to the laboratory of the psychologist.

Understand that in dealing with the phenomena of perception, the scientist has not been primarily concerned with art. His struggle has been to understand why man sees the way he does, how he senses form, space, color, how he orients himself within the world, and how much the human brain and human intelligence contribute to the magic process of seeing.

It has been the writer's problem to delve into all this, to try his best to comprehend, and then to interpret technical findings in esthetic terms—reducing his conclusions to fairly simple principles which might be comprehended without undue difficulty. This has not been an offhand chore by any means. Yet just as the Impressionist founded a new school of color in his day, so does it become possible to travel along new paths cleared by the psychologist and to establish still another and better school for the future.

Human perception is a fascinating area of study for the simple reason that it is related to the firsthand experience of everyone. It is not something apart from life, but intimately tied in with it. Thus everyone has access to the laboratory of his own consciousness. The way may not be too easy, but at least it is personal and not remote.

As a book, *Creative Color* illustrates and shows whereof it speaks. If what it has to *say* may seem involved and theoretical at times, what it has to *show* in color effect is straightforward enough. However, if what the reader sees does not happen to strike his fancy, it is hoped at least that some originality will be evident. It is this originality which has been the true purpose of the book.

In any event, the writer makes no pretense at being an artist. He has tried his best to inspire, honestly hoping that men of far more competent talent will pick up from where these pages leave off and reach new goals of expression to mark still further progress in the age-old art of color.

Faber Birren

PART I

1. Prelude to the Academic

There are several possible ways of writing a course of instructions in the field of color. One approach would be to write a series of essays, replete with inspiring statements—and in a manner quite typical of dissertations in the arts. However, being attracted to the new science of semantics, I realize that effusion is no credit to anyone. Because there is so much to be said and shown about the subject of color, I have tried to present the material as simply and clearly as possible.

The course which follows is divided into two sections. The first is devoted to pure, academic tradition. I have gone about it as if my audience comprised beginners. Frankly, these preliminary exercises bear resemblance to the playing of scales in music and to the parsing of sentences in grammar. The beginner may learn from them, while the more experienced reader may find them valuable as refresher material in the field of color.

Fundamental training in color is grounded on the basic work of M. E. Chevreul, and many other men, several of whom were educators. The contributions of Chevreul, Ogden Rood, Louis Prang, Milton Bradley, Albert Munsell, Denman Ross, M. Luckiesh, Walter Sargent, Herbert E. Ives, Arthur Pope, and Wilhelm Ostwald have been carefully studied and interpreted, and are presented in the first section.

In the second section, (which begins on page 60), more complex principles are discussed. The going will be less easy, and the more experienced reader may find that greater intellectual effort is necessary.

As will be emphasized later on, formal training does not in itself lead to art. If it did, mere academic concentration would create artists. At the same time, anyone who disparages training may do real harm to himself and put shackles on his native talents. One may dream a great symphony or a novel, but if he doesn't know keys and

counterpoint, or words and sentence structure, he will be in difficulties. I see no difference in the matter of color. If one fears that he may injure his soul with such pedantics, his soul can't be a very large one. The real advantage of thorough training is that although it can be ignored, it is not likely to be forgotten. The facility it gives to the eye and mind well serves anyone who wishes to give wings to his fancy.

Each chapter contains suggested experiments so that the reader can prepare a series of visual notes as he follows the text. Carrying out these demonstrations in actual color will greatly enhance his understanding of the principles presented in the book.

As I have pointed out in the Foreword, the art of color is a progressive one. While better knowledge of the workings of human perception may not in itself guarantee originality, at least it offers new wellsprings of inspiration. Viewpoint is all-important to the artist. He wants to think in new ways, to break with tradition and express something individual and pertinent to his times. He can do this with color, for this is one area where man has learned much and can far surpass the insights of the past.

Finally, a word about the color plates. They have been made broad in scope; both abstract and realistic styles are included so that all interests in art forms may be served. Since some readers may prefer realism, and others may prefer non-objectivism, I ask that the plates be visualized as *color studies*, not works of art; the effects themselves should be abstracted from the form in which they are presented. The plates are meant to speak for themselves, as original and striking examples which point to new directions. I have tried to tell how I developed them both in conception and execution. In addition, I have listed in Munsell Notations the exact colors and tones employed in each instance. The artist may copy them if he wishes, but when he has mastered the material, I hope he will venture on his own and go far beyond them.

Although a color such as red has a singular emotional impression, it can take many forms in the matter of design, texture and the like. The artist is forever free to work with color in any expression, realistic or abstract, which strikes his fancy.

2. Color Terms

The great English artist Constable once wrote, "Painting is a science and should be pursued as an inquiry into the laws of nature." This is certainly true of color. Nature herself organizes color in the rainbow, in the gradation of hues in a sunset. Such blending is definitely related to natural phenomena and has a scientific and mathematical basis.

An artist does not have to possess a knowledge of physics but, as Constable stated, he should study nature. Great artists of the past have understood this and have searched for understanding through their own powers of observation (if not through textbooks).

Everyone has to know the tools of his trade. The artist must be familiar with color terms to that he can create order out of what might otherwise be haphazard. He should know that there is science to color, not only as sensation he experiences in response to radiant energy, but also as sensation that is modified by his perception of the external world. It is not essential for him to develop an analytical mind but a comprehending one.

Terms used in the study of color are often confusing. They exist by the score and are given different interpretation by the scientist, artist and layman. Yet a common ground of understanding is necessary if a knowledge of color is to be gained and if ideas about it are to be freely exchanged.

In the writing of this book much care has been given to words and definitions. While it would perhaps be difficult to choose a vocab-

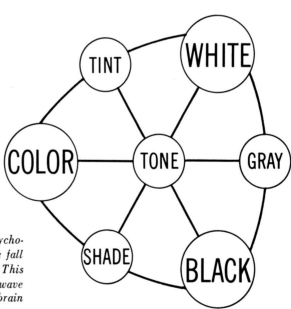

Figure 1. The Color Triangle. Visually and psychologically considered, all colors seen by the eye fall into one of the seven forms indicated here. This is color perception. Although innumerable wave lengths and degrees of brightness exist, the brain tends to give them simple order.

ulary that would satisfy everyone, it at least is possible to respect the best of tradition and common usage and to adhere to terms which have the benefit of widespread acceptance.

Colors and color variations will be described on a very simple and meaningful basis. Refer to the Color Triangle in Figure 1. This neatly charts a natural order for color in human experience.

There are *pure colors*, such as red, yellow, green, blue (also to be described as *hues*).

There is *white*.

There is *black*.

There is *gray* which may be formed through a combination of white and black.

There are *tints* (pink, lavender, peach) formed by mixing pure colors with white.

There are *shades* (brown, maroon, olive) formed by mixing pure colors with black.

There are *tones* (tan, beige, taupe) formed by mixing pure colors with white *and* black (or with gray).

Each of these terms is significant enough. Each may be readily understood and defines a type of color that differs visually and psychologically from all the others.

However, other color terminology is unfortunately less direct. The word *color* itself, in scientific and common usage, refers generally to all visual sensations. Chromatic colors are those with the quality of hue in them. Achromatic colors are the so-called neutrals, white, gray and black. In a broad sense, white, gray and black are colors. As scientists have noted, black is far from negative: it differs from the absence of sensation. Black affects the appearance of such hues as

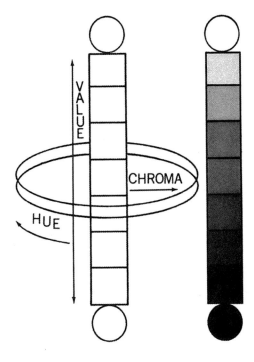

Figure 2. Colors may be described in terms of hue, value, chroma.

orange and yellow, turning them to brown and olive. It therefore is a color in the liberal meaning of the word because it is a definite kind of sensation and has very much of a positive influence on all hues.

Now refer to Figure 2. This diagram illustrates a second method of color description. Any given color may be defined in terms of *hue*, of *value* (lightness or brightness) and of *chroma* (intensity or saturation.)

Hue is the term used to distinguish one chromatic color from another, red from orange, orange from yellow, etc. Rose has a reddish hue, ivory has a yellowish hue, etc.

Value is the term used to distinguish the

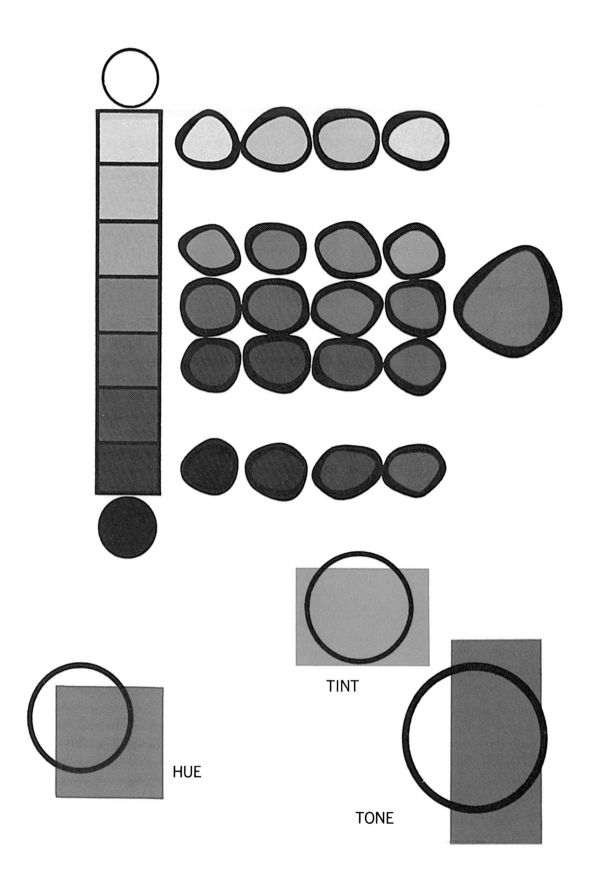

HUE

TINT

TONE

14

apparent lightness or darkness of a color. Pink is a color of high value, maroon a color of low value. The comparison is usually made with reference to corresponding steps or values on a neutral gray scale. Lightness is a synonym for value, and so is brightness —although this latter term is usually restricted to discussions of illumination rather than pigments, dyes or materials.

Chroma refers to relative purity or grayness of a color. The term was given this meaning by Albert H. Munsell and is an excellent one. Orange is a color of strong chroma. Tan is a color of weak chroma. The comparison is usually made with reference to degree of departure from a neutral gray. This dimension of color has often been called intensity. Many scientists use the term saturation.

Colors of strong chroma (intensity or saturation) are those that approach the likeness of pure hues. They may be high in value, like yellow, or low in value, like violet. A vermilion red will have a stronger chroma than a blue-green. Colors of weak chroma are those that approach the likeness of neutral gray.

Thus in Figure 2, hues will be found on the circle that runs around the central axis. Values refer to lightness toward white or darkness toward black. Chromas are weak or strong depending on whether they are grayish or pure.

Frankly, there is little need for terms beyond these few, although many others are to be found in the literature of color, art and science. A limited amount of training should enable anyone to speak and write coherently, to understand and make himself understood by others.

As to unique names for the quality of hue, most persons will readily comprehend the following designations. Among pure colors, there is order and clear meaning in red, orange, yellow, green, blue, violet, purple. Turquoise may be safely used to distinguish a greenish blue. Magenta may be used to distinguish a purplish red. Compound terms will likewise be significant: yellow-orange, yellow-green, blue-green, etc.

Among tints, the most readily understood are pink, flesh (or peach), ivory, cream, lavender. Among shades there are maroon, brown, olive, navy. Terms for tones are less

SHADE

Colors may be organized in different ways. The scales on the opposite page agree with the sequences indicated in Figure 2. The examples of hue, tint, tone and shade are from Figure 1. For other types of organization see pages 30 and 43. All orderly sequences of color seem to have harmonious beauty.

common. However, the following few may hold meaning: rose, tan, beige, taupe, ecru.

It will be noted that words for modifications of warm hues are more prevalent than words for modifications of cool hues. This is because the tints, shades and tones of warm hues are likely to have a markedly different appearance from their pure originals. For example, pink is quite unlike red, lavender is unlike purple, brown is unlike orange, and olive is unlike yellow. But tints and shades of cool hues such as green and blue still hold the same visual quality and remain, substantially, green and blue.

In the course of this section a few additional terms will be defined when they are mentioned. Meanwhile it will be well for the reader to clarify his own thinking and to see how well he can translate visual experiences into words. Let him remember that the word *color* itself refers to sensation. (Unseen by the human eye, color is radiant energy.) Colors are not properties of surfaces or objects but of human perception.

As this book will attempt to make clear, the whole experience of color is influenced not alone by light energy which enters the eye from the world beyond, but by subjective factors that arise from within the brain. Color is not only seen but "felt" emotionally. These personal interpretations are what make color such an intriguing field.

Experiments

Choose various colors at random and describe them through two methods.

A. Is a given sample a pure hue? Is it white, black, gray; a tint, a shade, a tone? Almost any sample selected may be conveniently identified as being one of these seven forms.

B. With a given sample, what is its hue? Is its value high, medium or low? Is its chroma strong, medium or weak?

Examples: (A) Pink is a tint. (B) Pink is a red hue of high value and medium chroma.

(A) Red is a pure color or hue. (B) Red has medium value and strong chroma.

(A) Maroon is a shade. (B) Maroon is a red hue of low value and medium chroma.

(A) Rose is a tone. (B) Rose is a red hue of medium value and medium or weak chroma.

3. Color Circles

When a beam of sunlight is directed through a prism, a spectrum of pure colors is formed. (See Figure 3.) This spectrum has a natural, scientific order. It extends from red, a color of long wave length and low frequency, through orange, yellow, green, blue into violet, a color of short wave length and high frequency. The spectrum of sunlight is without true purple.

Purple is formed when the red and violet ends of the visible spectrum are brought together and blended. This suggested to Sir Isaac Newton the idea of charting colors in the form of a circle (in about 1666). He consequently developed the first of all color circles. (See Figure 4.)

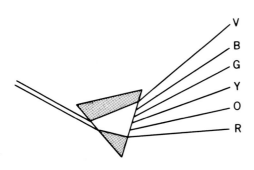

Figure 3. The spectrum. Red is a color of long wave length; violet is a color of short wave length.

Newton in his time chose seven hues (red, orange, yellow, green, blue, indigo, violet) to agree with certain more or less mystical notions about the seven notes of the diatonic scale in music and the seven planets of classical tradition. Since then numerous scientists and artists have studied the matter of color circles and have come to various conclusions.

It should be recognized that arguments about color circles may lead to futile debate. Most such differences of opinion are meaningless. At best, a color circle represents a neatly arranged sequence of pure hues about an equator. And almost any well-designed arrangement has merit to it.

Traditional in the field of art is a color circle based on red, yellow, blue. It has found best expression in America through the work of Herbert E. Ives. It is chiefly a color-mixture diagram and as such, is quite acceptable. Circles have been designed by physicists and based on red, green and blue-violet. The Ostwald circle recognizes red, yellow, green, blue. The Munsell circle has five key hues: red, yellow, green, blue, purple.

Various color circles are shown in Figures 4, 5, 6 and 7. The first (Figure 4) is Newton's circle, which has been already mentioned. Although red and violet lie at opposite ends of the spectrum and are the farthest removed of all hues in the spectrum, Newton noted a visual resemblance which enabled him to bring the two ends together to form a circle. Mixtures of red

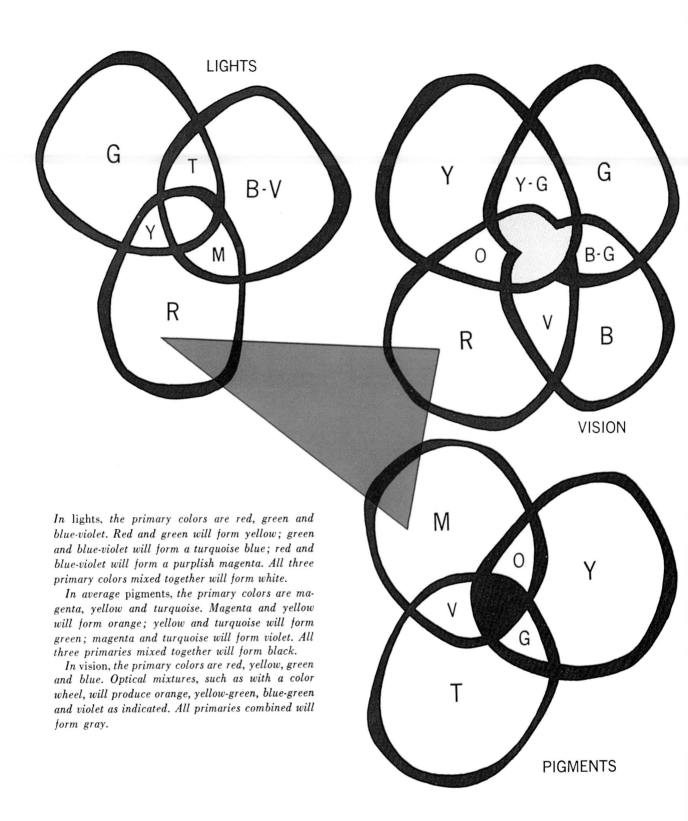

LIGHTS

VISION

PIGMENTS

In lights, *the primary colors are red, green and blue-violet. Red and green will form yellow; green and blue-violet will form a turquoise blue; red and blue-violet will form a purplish magenta. All three primary colors mixed together will form white.*

In average *pigments, the primary colors are magenta, yellow and turquoise. Magenta and yellow will form orange; yellow and turquoise will form green; magenta and turquoise will form violet. All three primaries mixed together will form black.*

In vision, *the primary colors are red, yellow, green and blue. Optical mixtures, such as with a color wheel, will produce orange, yellow-green, blue-green and violet as indicated. All primaries combined will form gray.*

and violet produce purple which is more or less a "visual" color and has no existence in the spectrum.

The Ives color circle (Figure 5), has its primaries in magenta red, yellow and turquoise blue. It is chiefly concerned with mixtures of dyes and pigments, although it has good visual order as well.

The Ostwald color circle (Figure 6) has primaries in red, ultramarine blue, seagreen and yellow and is based on the psychologist's concept of color.

The Munsell color circle (Figure 7) has primaries in red, yellow, green, blue and purple. Like the Ostwald, it is related to visual order and sequence.

All of these circles hold merit. Technically, there are sound reasons for color circles to have different primary elements.

—In the physics of light, red, green and blue-violet are fundamental; light mixtures of these colors will form other pure colors.

—With pigments and dyes, a magenta red, a clear yellow and a turquoise blue will similarly combine to form other pure hues.

—In human vision, the eye recognizes four elementary colors—red, yellow, green, blue—and each of these is again primary.

Unless a particular medium and viewpoint are set forth, it is easy to appreciate that arguments may be specious. Those who work with pigments still need a red, yellow, blue chart (more properly, magenta, yellow, turquoise, according to Ives). This arrangement expresses simple laws of color mixture and offers a satisfactory visual diagram. Yet, the circles of the physicist, of Ostwald and Munsell, should also be known and studied, for all of them are good charts

Figure 4. Newton's Color Circle.

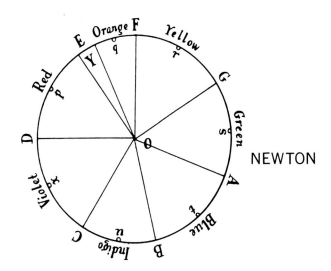

NEWTON

—no one better than the other—and each is entirely defensible.

What is fundamentally required, perhaps, is some sort of organization. Harmony, for example, is achieved where major principles are respected. Whether yellow finds its exact complement in violet, blue, or blue-violet is not too significant. To insist to the contrary is to give way to a pedantic viewpoint—whereas free creative expression needs greater tolerance.

The red, yellow, blue color circle has been used in this book both to describe color mixtures and to work out principles of color harmony.

The primary elements are a magenta red, a yellow and turquoise blue. These three basic hues were brought to perfection by Herbert E. Ives and represent the minimum "primary" colors which, in combination, will produce a full array of fairly pure intermediates using average pigments. (Ives used the term *achlor* for magenta, *zanth* for yellow, and *syan* for turquoise blue.) Mixtures of magenta and yellow form reds and oranges. Mixtures of yellow and turquoise form greens. Mixtures of magenta and turquoise form purples and violets. These three, in other words, are the fewest that can be employed to produce a satisfactory color circle. For rich, powerful hues, however, more than three colors become essential.

On the Ives color circle, opposite hues are arranged in this order:

Magenta—Green	Yellow-Orange—Blue
Red—Blue-Green	Yellow—Violet
Orange—Turquoise	Yellow-Green—Purple

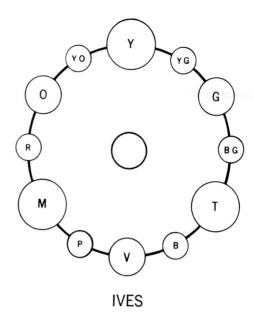

Figure 5. The Ives Color Circle.

In the main, the above pairs of opposites are significant on two counts. First, they represent average pigments which, when mixed together, will neutralize each other and produce grays. Second, they are fairly accurate visual complements and will also form grayish tones when spun on a color-wheel.

The Ives circle will be referred to frequently in the pages that follow. It affords a simple and remarkable graph of color arrangement and sequence. Beyond it, however, there is advantage in becoming familiar with other types of color circles, such as the Ostwald and the Munsell.

Experiments

In color training one of the best initial experiments is to develop a color circle which more or less expresses the personal feeling of its creator. To do this, take a series of pigments such as magenta, orange, yellow, green, turquoise and violet, and mix them together in analogous order. Without having any preconceived color circle in mind, a straight row of intermediate hues should be formed. Steps should be mixed between magenta and orange, between orange and yellow, yellow and green, and so on, until a complete spectrum has been worked out. The object, of course, is to have all the steps appear equally removed from each other in visual difference—whether in the warm or cool region. When this has been done, the colors should then be pasted in the form of a circle.

As human temperaments vary, so will the color circles vary. Persons of a frank and impulsive nature may be inclined to mix few steps. More deliberate and meticulous persons will work out a closely related series of steps with many more gradations. One result will naturally be as good as the other. The experiment, simple in its conception, will help to encourage a freer and more creative attitude—as opposed to strict training which frequently curbs initiative.

Figure 6. The Ostwald Color Circle.

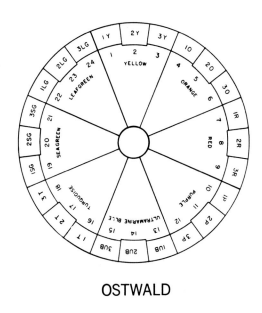

OSTWALD

MUNSELL

Figure 7. The Munsell Color Circle.

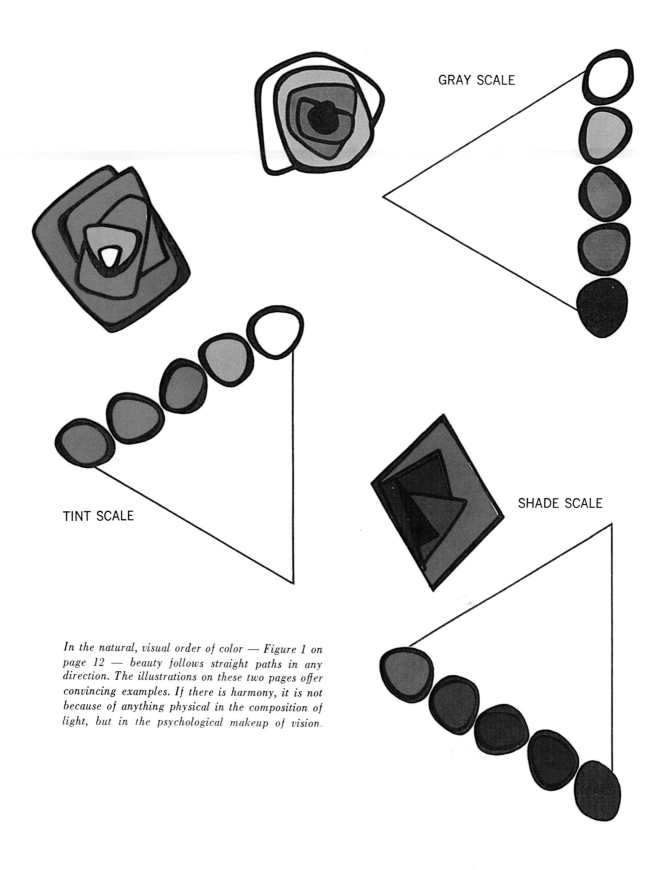

GRAY SCALE

TINT SCALE

SHADE SCALE

In the natural, visual order of color — Figure 1 on page 12 — beauty follows straight paths in any direction. The illustrations on these two pages offer convincing examples. If there is harmony, it is not because of anything physical in the composition of light, but in the psychological makeup of vision.

4. Color Scales

Almost any orderly sequence of color will appear pleasing to the human eye. Thus color systems in general have an inherent beauty—the Ives, Ostwald, Munsell, and others.

Yet in this book, overemphasis on the highly technical problems of scientific color organization will be avoided. Where artistic expression is concerned, the process of training should open the mind rather than confine it. For some reason or other, training in color too frequently gets lost in a maze of fussy detail. An artist perhaps has no more reason to work out the involved details of a color system than a pianist has reason to build a piano. Too much discipline of temperament runs the danger of discouraging the spirit rather than leaving it happily free. Science is essentially intellectual; art is essentially emotional.

Thus to acquire some adeptness in working with color it may be best to let the more formal aspects of training remain as natural and unencumbered as possible. This has been suggested with reference to color circles; it also is suggested in practicing with color scales.

Pure colors may be graded in any number of ways: simple additions of white; additions of black; or additions of gray. In each instance a different and concordant series of tints, shades and tones can be formed. In the experiments to be described in this and following chapters, black and gray as mixing agents will be continually mentioned. The reader is not to assume from this, however, that modified colors should invariably be formed in this manner. As will be seen later, pure colors may be grayed or otherwise toned by mixing them in terms of complements (red plus blue-green, yellow plus violet, etc.). Many painters exclude black from their palettes because of its dulling effect upon pure hues.

However, because the immediate concern is with a study of *visual* order and analogy

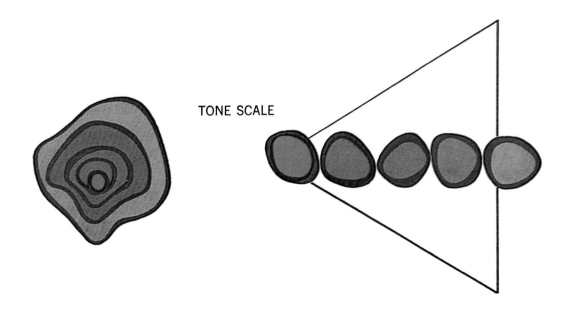

TONE SCALE

in color arrangement, the use of black and gray in pigment mixtures will serve a convenient purpose. Color scales are to be readily formed with them and will enable the artist to understand the several directions in which colors may be scaled—without at the same time complicating the technique of mixing them.

The first of all scales in importance is the gray scale formed by carefully graded mixtures of black and white. (See Figure 8.) Psychological study has shown that the average person will readily distinguish about nine steps from black to white. Middle gray (value 5) will reflect about 25 per cent of light. Thus if black and white disks are spun on a colorwheel, a middle-gray may be visualized by spinning 25 per cent white with 75 per cent black.

A gray scale is the backbone of color systems. Every worker in color should have one for reference. It may be used to measure the corresponding values of chromatic colors and to develop color schemes which have a basis in carefully arranged value steps.

As to chromatic scales, refer again to Figure 1. Scales formed by mixing pure colors with white are called *tint scales*. They are delicate and atmospheric in quality and seem to be associated with nature during the spring of the year.

Scales formed by mixing pure color with black are called *shade scales*. Here one sees the rich, deep colors of autumn.

Scales formed by mixing pure colors with gray are called *tone scales*. They are soft and neutral in character and somewhat associated with the muted colors of winter.

Figure 8. The Gray Scale.

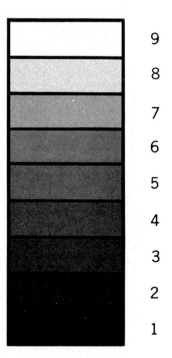

9

8

7

6

5

4

3

2

1

Vivid colors of strong chroma represent the spectrum itself and seem allied with summer.

Scales are also to be formed by following other sequences on the color triangle (Figure 1). Natural order exists in sequences that run from white through tone to shade, and from black through tone to tint. These perhaps are not quite as appealing as the simpler tint, shade and tone scales. Yet they have a subtlety to them which may suggest many possibilities. (See page 26.)

(Still other scales—the most beautiful of all—will be discussed separately in the next chapter. These are the *uniform chroma scales* and are composed of carefully graded mixtures from tint through tone to shade. See illustrations on pages 27 and 34.)

Pages 22 and 23 show tint, shade, gray and tone scales using red as a key hue. These illustrate straight paths traced in Figure 1. Although many of the colors are repeated, the sequences differ—and each is concordant. Such arrangements follow a natural law of vision which holds true, not because of extraneous physics but because of the psychological makeup of vision itself.

In the tint scale, the darker color (pure red) is strong in chroma, while the light pink tint is weak. In the shade scale, the pure red color is relatively light and the deep maroon color weak. In the tone scale, the sequence is from purity to a weak chroma of medium value.

Now look at the scales on page 26. Here the paths cross at angles on Figure 1. In the white-tone-shade sequence, the harmony goes from deep richness to pale lightness. In the tint-tone-black sequence, the harmony runs from pale richness to deep neutrality. The two effects are quite the opposite.

It is quite interesting to examine these scales. Although the same hue (red), tints, shades and tones are involved, each of the arrangements has a different "feeling" and perhaps a different emotional quality. This will depend on the natural or acquired predilections of the reader. The scales, harmonious though they are, are none the less somewhat academic. Even greater beauty lies in store—as will be found in the next section of this book.

Where color scales follow a consistent order, the eye is agreeably satisfied. In tint scales the common, harmonizing element is white. In shade scales, the harmonizing element is black. In tone scales the harmonizing element is gray. In chroma scales the element of color purity is held constant.

Experiments should be made with all scales, using different key hues. This will serve to familiarize the artist with the many attractive dimensions of color—harmonies which run in different directions but which are all pleasing because they all trace straight and orderly paths.

In working with *tone* scales (pure color, tone, gray) two principles may be followed. First, any and all pure colors may be scaled toward the *same middle-gray* (value 5). Such scales will be natural to the scientific arrangement of the Ostwald system. Second, any pure color may be scaled toward a gray having the same approximate value—yellow with light gray, red with medium gray, violet with deep gray, etc. This sequence will follow the order found in the Munsell system. Illustrations will be found on page 43.

Experiments

The artist should experiment with various color scales using different key hues.

Tint scales: pure colors should be mixed with white to form steps of tints.

Shade scales: pure colors should be mixed with black to form steps of shades.

Tone scales: pure colors should be mixed with gray to form steps of tones. In one order, all colors may scale to the same middle-gray. In the second, each pure color may be scaled toward a gray of similar value.

Other scales should be formed which scale from white to tone to shade, and from black to tone to tint.

As previously suggested in the experiments in Chapter 2 on color circles, the artist may mix as many steps in each scale as he wishes. Depending upon individual temperament, some persons may see few steps, others many. The important thing is to cultivate a feeling for colors in different modifications.

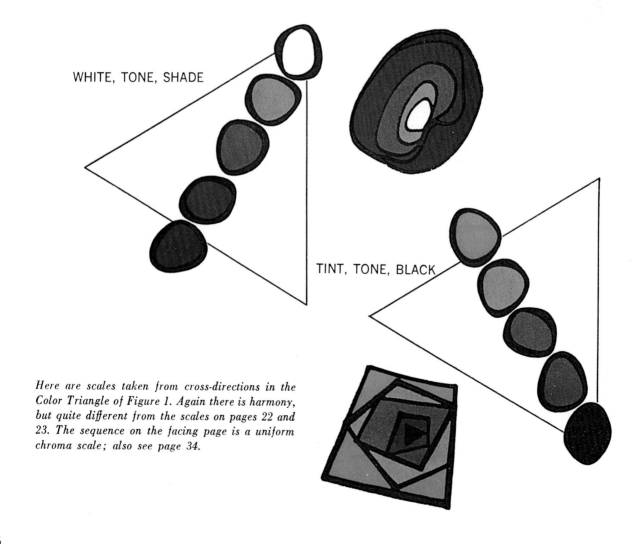

WHITE, TONE, SHADE

TINT, TONE, BLACK

Here are scales taken from cross-directions in the Color Triangle of Figure 1. Again there is harmony, but quite different from the scales on pages 22 and 23. The sequence on the facing page is a uniform chroma scale; also see page 34.

5. Uniform Chroma Scales

The most beautiful of all formal color gradations is that known as the *uniform chroma scale*—colors which have the same apparent color content but which differ in lightness and darkness. Yet it has been seldom described in books on color. To give it the distinction it rightly deserves, let me devote this special chapter to it.

Although color scales in general are common enough, the particular nature and quality of the *uniform chroma scale* has been largely neglected. Yet it offers appealing dimension to abstract color harmony, and a knowledge of it is almost indispensable in pictorial art. Great painters have known of it, probably through careful observation and intuition. However, its principles—which will be set forth here—should be known to everyone who is even remotely concerned with color expression.

To Wilhelm Ostwald goes credit for a glorification of the chroma scale and for a scientific definition of it. In his color system colors of apparently uniform hue content run in vertical rows about the gray scale. These colors he terms "isochromes," and they form the "shadow series" of his color solid.

To describe the natural order and beauty of a uniform chroma scale, when a tint such as pink falls into shadow, the softness of the gradation is not to be duplicated (with pigments) by adding simple proportions of black to pink. As the color drops in value, *the proportion of hue content remains constant*. What happens in a pink chroma scale is that the light tone may have a relatively large proportion of white, and the deep tone a relatively large proportion of black, but the proportion of color in any step of the series will remain substantially the same. This means, precisely, that deeper tones of pink when mixed with pigments should be formed by adding black, *plus a touch of the key hue itself* (pink or red) to the original mixture!

While scales of this type are not easy to form, they have an essential role in color training and have invaluable use where problems of highlight and shadow are encountered.

Ostwald was able to identify the uniform chroma scale ("shadow series") with the secret of *chiaroscuro* painting developed by Leonardo da Vinci—an effect that distinguishes the rich and luminous quality of

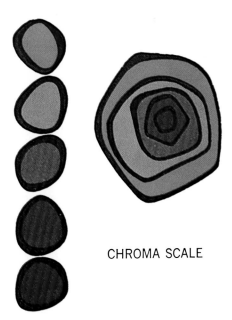

CHROMA SCALE

much of the work of the Old Masters. In the *chiaroscuro* style, highlights and shadows are not formed by simple additions of white or black to a given color. Such a practice would produce an unreal and often ungainly effect. Lower values of a tint are to be formed by adding black plus a touch of color as the scale grows deeper. Higher values of a shade are to be formed by adding white plus a touch of color as the scale grows lighter. With a tone, white plus a touch of color will be required to go up in value, and black plus a touch of color to go down in value.

Pure colors, in shadow, may require black only. However, the problem here is best solved by using deeper pigments—additions of maroon to produce shades of red, or burnt sienna to orange. Highlights on pure colors likewise are best featured by selecting a brighter pigment—such as vermilion to highlight red.

Ostwald also drew attention to certain practices in the use of color which produce shoddy results. With dyes and pigments, for example, commercial practice often resorts to the formation of color scales in which basic hues or "toners" are merely diluted to form lighter tints. This may result in effects in which highlights are weak in chroma and shadows strong in chroma—an appearance that is wholly unnatural. Ostwald wrote: "The low condition of our feeling for color harmony is characterized hardly anywhere or anyhow more clearly than by the fact that this radically false method is being practiced up to this day without misgiving."

Carefully mixed chroma scales are a de-light to behold. Practice with them is both gratifying and enlightening. While the next chapter will present a mathematical formula to achieve them (by matching pigments against color-wheel measurements) they may also be formed through simple visual judgment.

The principle is to create high and low values of colors (preferably tones) by adding white plus a touch of hue to get higher values, and by adding black plus a touch of hue to get lower values. The hue content, regardless of value, will always appear to be uniform. For reference it is interesting to study the action of natural shadows on a curved object, or flat areas of color held at various distances from a light source.

The process of mixing pigments will not, unfortunately, be too easy. To make a uniform chroma scale of pink, for example, the high value may consist merely of white and red. As deeper values are mixed, black plus a touch of red will be added. If the scale extends down to maroon, the low value may have no white in it at all and may be comprised solely of red and black. Each step in the scale, however, whether light or dark, will appear to contain the same amount of hue.

One easy way to form uniform chroma scales is to mix a tint, a tone, and a shade of the same hue and then intermix them for in-between steps.

Uniform chroma scales, using red as a key hue, will be found on pages 27 and 34. In academic or formalized color harmony, such sequences are eminent. If the reader will study the paintings of the Old Masters, he will discover for himself that Da Vinci,

Titian, Raphael, Rembrandt, modelled their colors in this way. Previously, artists—such as Giotto—merely worked with base colors which they tinted or weakened with white to effect lighter tones—or added black for shades.

The uniform chroma scale not only assures startling realism in representational art but it has its beauty and value as well in abstract and non-objective art—and, indeed, in commercial design.

It is indifferent practice to use a palette of pure pigments and then to work primitively with admixtures of white or black—or even complementary hues. Simple, everyday things, such as textiles, all too frequently show this carelessness. They can be given real magnificence if the principle of the uniform chroma scale is respected.

What is important to the reader, perhaps, is that he understand the uniform chroma scale. It may be that he has not been too conscious of it. Such knowledge is almost indispensable to anyone who works realistically; and in abstract or commercial design, it can well spell the difference between what is ordinary and what is exceptional.

Color training is vital for its enlighten-ment. If it seems to be academic, this can be forgotten. The true artist is the one who has a grasp of natural laws—and the magic of his own perception.

Experiments

The Ostwald system is well organized in terms of uniform chroma scales and may be referred to if desired. Color-wheel measurements for three chroma scales are also given in the next chapter.

Mix a variety of uniform chroma scales using different key hues. Good practice and skill will follow experimentation with graded lower values of tints such as peach, pink, lavender, pale blue—and with graded higher values of shades such as brown, maroon, deep blue, violet, green.

Also, tones of medium value (tan, rose, powder blue, sage green) should be scaled into higher and lower values as explained in this chapter.

Such scales should be carried out in simple abstract designs. The best backgrounds to use are neutral grays or soft grayish tones.

This is an elaboration of the Color Triangle shown in Figure 1 on page 12. The tints, shades and tones included have all been derived from mixtures worked out on a color wheel, using the formulas given below in Figure 9. Note harmonious sequences in all directions. Here mathematics has been used to organize human perception.

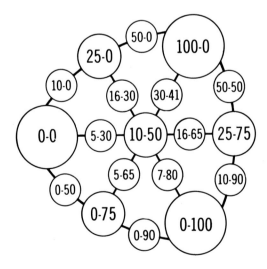

Figure 9. The Birren Color Equation.

6. Color Organization

Scientific color organization is perhaps more important to the problems of color standardization and designation than to the problems of art and color harmony. In the technical study of color systems one may be asked to

Figure 10. Arrangement of black, white and pure color disks for color-wheel measurements.

leave much initiative aside and renounce creative feeling for an impersonal adherence to set rules. While formal training in color systems has some merit, it is far better for advanced students than for beginners. It may curb originality rather than inspire it.

Good color systems, such as Ostwald and Munsell, are not in themselves answers to beauty. The artist should understand that organization in color is required where the world of color forms is to be intelligently plotted, where permanent standards are to be set up for reference, or where a useful system of notations is to be recorded. Yet to

stimulate esthetic feeling, to make the spirit eager, it is best to devote time to less conventional training.

No artist should fear knowledge, even if it is academic. The designers of a space ship —which is certainly new under the sun— must be adept at higher mathematics which trace back to ancient Greece. Certainly he would not forego such training even though he may be creating something which man has never seen before.

The artist really isn't much different— particularly regarding color. If he dreams of creating something new, it would be inconsistent for him to work primitively on his own. This might be acceptable in relation to his basic concepts of beauty, but the skill-

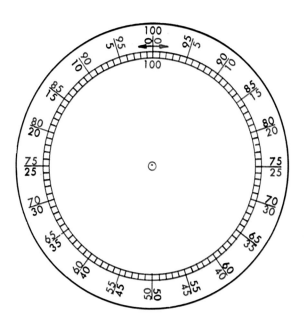

Figure 11. Calibrated disk for color-wheel measurements. The clockwise scale (red figures) is used for the measurement of white content. The counter-clockwise scale (black figures) is used for the measurement of black content. The amount of color is the sum left over to equal 100.

31

ful manipulator of color ought to exploit and build upon a carefully amassed fund of information.

Before the matter of color organization and color scales is set aside, let me review one mathematical formula. The artist may experiment with it as he desires. It will indicate that science is able to measure color sensations and reduce them to simple equations. The many colors and color variations seen by the human eye are to be analyzed and arranged with surprising accuracy.

Refer to Figure 9. This equation has been devised by the author and expresses, in mathematical terms, the principles of color arrangement previously described in connection with the color triangle of Figure 1. The whole plan of the equation is directly related to the work of Ewald Hering, a famous psychologist, and Wilhelm Ostwald. It plots colors in neat visual and psychological order—and it uses mathematics rather than "feeling" to accomplish this.

In each instance, the *first number* gives the *white content* of each color, and the *second number* gives the *black content*. The hue content is not included; it is the difference between the sum of these two numbers and 100. (All measurements are made on a color wheel.)

Vertically at the right is the gray scale. All numbers in this row add to 100 and thus form gray steps in which the quality of hue is absent. There are five steps here: 100–0, 50–50, 25–75, 10–90, 0–100.

A pure tint scale (without any black in it) runs from pure color to white: 0–0, 10–0, 25–0, 50–0, 100–0.

A pure shade scale (without any white in it) runs from pure color to black: 0–0, 0–50, 0–75, 0–90, 0–100.

A tone scale runs horizontally from pure color to gray: 0–0, 5–30, 10–50, 16–65, 25–75.

The above scales will be found illustrated —using red as a key hue—on pages 22 and 23.

There are also two diagonal scales. In one the sequence is from white to shade through tone: 100–0, 30–41, 10–50, 5–65, 0–75. In the other the sequence is from black to tint through tone: 0–100, 7–80, 10–50, 16–30, 25–0. These will be found illustrated on page 26.

Finally, there are three uniform chroma scales—the most beautiful of all.

A	B	C
	25–0	50–0
10–0	16–30	30–41
5–30	10–50	16–65
0–50	5–65	7–80
	0–75	0–90

Here the color scales vary in different amounts of white and black, but the hue content will appear to be equal in each vertical row. One scale (left), with three steps, will be relatively pure. One scale, (center) will be more or less midway in chroma. The third scale (right) will consist of soft gradations near the neutral gray scale. For illustrations using red as a key hue, see pages 27 and 34.

The Color Equation is a fascinating chart. It takes the natural, visual order of color scales and reduces it to mathematical equations. Thanks to Hering and Ostwald, psy-

chological and scientific factors may be brought into accord.

In working with the Color Equation, the following procedure is suggested. Disks should be prepared in pure color, black and white. These are then placed upon a calibrated scale (Figure 10) in which two 100 degree scales are plotted, one running clockwise and one running counter-clockwise. In Figure 10, the clockwise scale has been printed with red numerals and is used to measure white content. The counter-clockwise scale has been printed with black numerals and is used to measure black content. Selecting one pure color, it is combined with black and with white and placed on the color-wheel over the calibrated disk as shown in Figure 11. It is thus convenient to measure the white content against the red clockwise scale, and the black content against the black counter-clockwise scale. The hue content is always that sum which is left over to equal 100.

The various proportions given on the Color Equation of Figure 9 may then be spun, using white, black and a pure key hue. Paints may be mixed to match the results seen on the color-wheel. Some 13 tints, shades and tones, plus 5 gray steps, may

thus be formed. They will all fit neatly together like the parts of a jig-saw puzzle to form a balanced color chart in which harmonious sequence runs in all directions.

While certain mechanics may be required in experimenting with the Color Equation of Figure 6, the effort may be worthwhile. As scales are formed in any direction, harmony will automatically be achieved. The artist will begin to think in terms of such elements as whiteness, blackness, grayness and to understand *visual* color arrangements which lead to remarkable effects.

Then after the demonstrations of the color wheel have been experienced, the medium may be set aside, for the artist should have an excellent knowledge of psychological order in color and be able to move freely on his own and without reference either to mathematical formulas or color wheels.

Work with the Color Equation may require patience and care. Yet the result should be gratifying. Color systems in general should be easier to understand. The artist should be better able to "think" with color, to plan for effects having different emotional qualities. He should appreciate that he can control his medium and not be obliged to resort to haphazard methods.

Experiments

Depending on degree of interest, one or a series of complete color triangles should be worked out by matching paints against color-wheel measurements.

One good project is to mix colors from

formulas chosen at random from the equation. A complete chart may then later be pasted up—and should fit together perfectly.

Another experiment is to take a simple

abstract design and mark it in pencil with formulas from the equation. Using one key hue, harmonies may be plotted in vertical, horizontal or oblique rows. Special attention may be given to the chroma scales. The artist may then match tones against the color wheel and fill in his design. Such exercise will help to stimulate abstract thinking and to encourage the artist to visualize effects before his colors are mixed or applied.

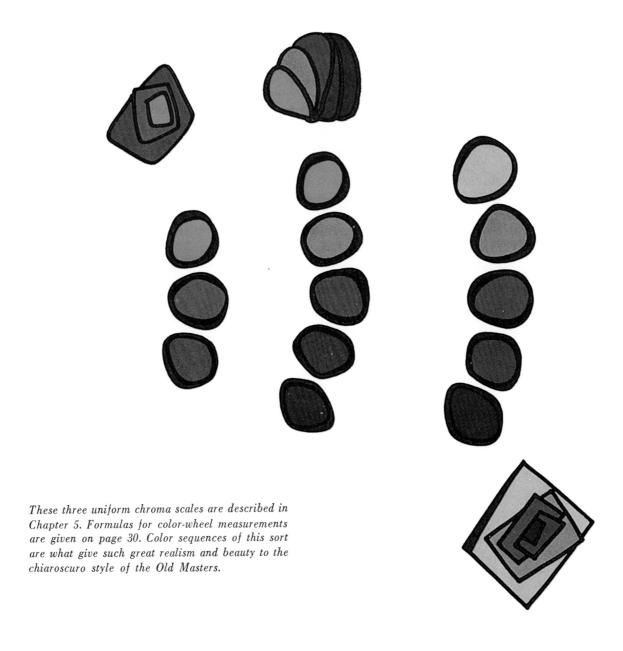

These three uniform chroma scales are described in Chapter 5. Formulas for color-wheel measurements are given on page 30. Color sequences of this sort are what give such great realism and beauty to the chiaroscuro style of the Old Masters.

7. Color Mixture

At this point it is hoped that the reader will have a fairly good understanding of the more orderly and systematic aspects of color. This is essential knowledge, and helps to lend coherence to the more general study of the subject and to make clear that the world of color sensation has sense and sequence.

Yet scientific color organization should perhaps not be overstressed. Broad principles are what count most. A detailed study of color systems may be all well and good to gain familiarity with the technical side of color. Such pedantic exercises are mere groundwork and hardly suffice for creative expression. Artistic feeling needs broad space, not confined channels.

In contrast with the previous chapter in which color has been studied under strict control, let me now encourage more initiative and freedom in the manipulation of color mediums.

As explained in the chapter on color circles, pure hues such as magenta red, yellow and turquoise blue may be combined in pigments to form other hues like orange, green and violet. In process printing, in the intermixture of paints and dyes, the above three key hues will form a fairly intense duplication of the spectrum. The principle has been set forth by many great colorists of the past.

However, three colors are never enough to satisfy *every* desire to produce colors of strong chroma. Purplish red and turquoise blue, for example, will form a purple—but not an intense one. Nor will mixtures of them produce a brilliant ultramarine.

The fewest basic colors necessary to form a spectrum or color circle of *high intensity* are five in number: a vermilion red, a clear yellow, a turquoise blue, an ultramarine blue and a purple. In fact, expression in

Although the color components may be the same, there may be a big difference in effect between a thorough mixture of paints and a free and textured handling of them.

color is best served where the artist uses several rather than few colors—the more the better. Where effective results are wanted, a full palette will make them possible. Otherwise, major effort may be spent in the mixture of paints rather than in the free application of them.

There are certain facts about color mixture which should be known.

Vermilion red and a warm yellow-orange will combine to form an intense series of orange hues.

Turquoise blue and a cool yellow will form a vivid series of yellow-greens and greens.

A purplish red and an ultramarine blue will form rich violets.

The pure hues which are almost impossible to form through intermixture are magenta, vermilion red, yellow, turquoise blue, ultramarine blue and purple. Secondary hues such as orange, yellow-orange, yellow-green, green, blue-green and violet are simply enough formed by combining hues which lie adjacent to them on the color circle.

Where the quest is for softness rather than high intensity, many beautiful tones are to be formed by combining intermediate rather than primary hues. The colors created in this manner are often called tertiary hues.

Thus orange and violet will mix to a soft red of low chroma.

Green and violet will mix to a soft blue.

Orange and green will mix to a dull yellow (having an olive or tannish cast).

It will at once be recognized that grayish tones and deep shades of pure colors need not be formed by using gray or black. Where soft tones are desired, beautiful and subtle results may be assured by combining intermediates or complements.

Refer again to the color circle, Figure 5 on page 20. Any key hue is to be grayed by adding a touch of its opposite. A touch of green will soften magenta. Blue-green will soften red. Turquoise will soften orange. Blue will soften yellow-orange. Violet will soften yellow. Purple will soften yellow-green. Conversely, a touch of magenta will soften green. Red will soften blue-green. Orange will soften turquoise. Yellow-orange will soften blue. Yellow will soften violet. Yellow-green will soften purple.

Other interesting mixtures are also to be produced. Brown, for example, may be formed in a number of ways: orange plus black; orange plus blue; yellow plus red and blue; orange plus green and violet.

Neutral grays may also be produced in the above fashion, although an extremely delicate balance of pigments may be required. This is one of the most difficult of all experiments in color mixture.

In pictorial art, a generally refined and appealing blend of colors will follow this mixture of complements or near-complements. With oil paints, for example, mixed tones will not appear flat but will tend to scintillate because of the variety in the color mixture. The technique requires more skill

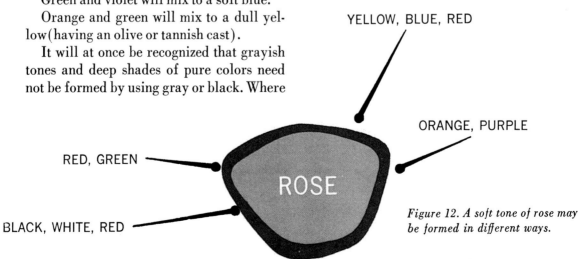

Figure 12. A soft tone of rose may be formed in different ways.

than would follow the simple addition of black or gray to pure hues. However, the extra effort will have many rewards and will help save many creative works of art from appearing dull and muddy.

Here are a few additional notes on color mixture.

True tints, pink, lavender, peach, etc. may require the addition of white to pure color.

Many true shades, such as maroon, navy blue, deep violet and purple (but not brown) may require black if rich shades are to be formed.

The illustration on page 35 suggests how color mixtures may be manipulated to create different surface effects or textures. A thorough mixture of pigments—such as red, black and white—may result in a flat and characterless tone. However, if the colors are not intermixed but "dragged" together over a surface, more interest and "microstructure" may be achieved. Although the colors in both cases may be the same, the visual effect will be far different.

In the black and white diagram of Figure 12 indications are given as to how a tone of rose may be formed in four different ways. (The same principles may be applied to color tones in other hues.) Skilled painters often know these various paths to one and the same result. If the pigment mixtures are freely handled—and not too thoroughly mixed—the tones will scintillate because the eye will be treated to glints of the hues that compose them. Color expression was revolutionized in this way during the time of the Impressionists.

Experiments

Tertiaries should be mixed by combining orange and violet to form soft red, green and violet to form soft blue, orange and green to form soft yellow (or tan).

Grayed tones of pure colors should likewise be formed through the mixture of complements: magenta with green, red with blue-green, orange with turquoise, yellow-orange with blue, yellow with violet, yellow-green with purple.

Browns should be mixed in accordance with the notes of this chapter.

One very enlightening exercise is to attempt to mix a soft grayish tone of rose (as in Figure 12) in different ways—and to have the results of all mixtures be as similar as possible. Here are a few formulas to follow in forming a grayish rose: vermilion red plus white and a touch of black; red plus green; red plus a touch of yellow and blue; a combination of orange and purple.

The same principles may be followed in mixing grayed tones of other primary and secondary hues on the color circle.

SIMPLICITY UGLINESS BEAUTY

8. The Elements of Harmony

Before I delve into the mysteries of color harmony, here are a few words of caution. Rules and laws of color arrangement should never be taken too seriously. If a man is trained to arbitrary principles, he may discover later in life that such conventions have no great application either in commercial fields or the fine arts. Although beauty may be found to respect order in many instances, creative work itself can never be a matter-of-fact process. "Natural laws" of color harmony exist without question. They are interesting and valuable to study. Yet if one accepts them too completely, he may neglect his own personal feeling. Not only may he run the danger of becoming academic in his thinking, but his own sense of the artistic may be misled.

Color systems are by no means infallible. Before they become too fixed in memory or mind, the artist should grow familiar with a few general human reactions to color and to a number of factors that assure real appeal.

For example, the most preferred colors are blue, red and green. Color combinations in which one of these is dominant will nearly always satisfy most people. This means that no set rule of color harmony (adjacents, opposites, split-complements, triads, etc.) may be applied throughout the color circle with equal assurance of success. The opposites red and blue-green will nearly always be more compelling than the opposites yellow-green and purple. Thus it can hardly be said that opposites—any pair of opposites—will hold the same relative beauty.

Again, formal harmony with color will vary with respect to tint, shade and tone. When average persons are shown color scales that vary from light to dark, the lighter variations will be preferred to the deeper. When they are shown colors that scale from purity to grayness, the richer hues will be liked better than the neutral ones. Rules which throw such facts into collision may run contrary to human taste.

It should also be recognized that the eye sees definite order in the matter of color

The eye delights in simple and clear-cut colors, forms and sequences. Things which are vague, uncertain or "in between" will be disturbing and appear unattractive. Vision seems to want order and neatness and to be disturbed until good balance and proportion are evident.

form. The seven forms of color are those indicated in the triangle of Figure 1. They are: pure color, white, black; tint, shade, tone, gray. Individual colors are most beautiful when they represent clear-cut examples in any particular form. When pure hues are exhibited they should be vivid and intense. Pure red with a *touch* of white looks faded. Pure red with a *touch* of black looks dingy. Yet if enough white is added to turn red to pink, or if enough black is added to turn red to maroon, beauty will be restored as the color moves from a pure form to the precise form of a tint or shade. These simple facts are illustrated on page 38.

For the same reason, tints should be light and clean, and shades should be rich and deep. Tones should be mellow and grayish and not be confused with other forms. With single colors, ugliness seems to exist where they are difficult to classify, where they lie on borderlines and fail to exemplify clarity.

In a general way, the triangle of Figure 1 also teaches other lessons. A more or less primary order for color will be found in a combination of pure color, white and black. A secondary order will be found in a combination of tint, tone, shade and gray.

Where a color sequence follows a straight path on the triangle, the eye seems to be pleased. Pure colors go well with tints on a white ground. Pure colors go well with shades on a black ground. Pure colors go well with tones on a gray ground. Tints, tones and shades (chroma scales) are also beautiful, with the tone form being best for the ground.

All these arrangements are natural ones and are to be identified with the psychological aspects of color-vision. In tint scales the common harmonizing agent is white. In shade scales the common harmonizing agent is black. Gray "holds together" the tone scale.

Simplicity is always a good key to beauty and even applies to shapes as well as colors. The gestalt psychologist has pointed out that slightly distorted squares and circles, for example, may appear ugly. Yet where they are further refined to the shapes of rectangles and ovals, beauty seems to be restored.

Finally, let me describe another natural order for color harmony pointed out by I. H. Godlove. Tints of pure colors which are normally light in value (orange, yellow-orange, yellow, yellow-green, green) look best with shades of pure colors which are normally dark in value (purple, violet, blue).

This means, precisely, that pink will look better with violet or navy than lavender or pale blue will look with maroon. Peach and ivory will look better with deep reds, blues and violets, than very pale tints of red, blue or violet will look with brown, olive or deep green.

The rather surprising truth of Godlove's principle will be apparent when actual samples of tints and shades are arranged on a basis of personal taste. Nature herself follows similar order. The highlight of a color usually shows glints of its adjacent on the upper side of the color circle. Shadows usually drop toward the adjacent hue that is lower on the color circle. Thus, a red rose will have vermilion or orange highlights and purplish shadows. The modulations of a green leaf will swing from yellow-green in highlight to blue-green in shadow.

Experiments

To encourage a personal feeling for color, an artist may take samples of pure colors (red, blue, etc.) and paste them up in the order which he prefers. If desired, the same preference may be recorded for tints, shades and tones. This will chart his own color preferences.

To emphasize the desirability of clarity of form, one base color should be mixed in a variety of scales—toward white, toward gray and toward black. The artist should then check the tint he likes best, the preferred shade, and the preferred tone. This will be good practice in inspiring him to look for attractive qualities in color.

Godlove's principle should be studied. Combinations of tints and shades should be pasted up in accordance with the discussion of this chapter. The most pleasing arrangements should be noted.

9. Color Value and Sequence

The factor of *value* in color harmony is often given undue importance. Yet while the apparent lightness and darkness of colors is a quality recognized in human vision, it should by no means be allowed to dominate the quest for beauty.

To begin with, value is a relative and fugitive thing. Under intense light and using a black background, the halfway point between white and black is found in a gray that reflects about 18 per cent of light. On a white ground, this midpoint is found in a gray that reflects as much as 25 per cent. This is the formula shown in Figure 9. As general light grows dim, more and more reflectance will be demanded. In feeble light, medium-gray may seem to be located in a neutral that reflects as much as 50 per cent.

Obviously, if an artist or designer goes to extensive trouble in working out neat sequences in value, his whole effect may collapse if his creation is seen under different lighting conditions.

However, the greatest danger in overemphasizing value in color harmony lies in the formation of bad habits which may consciously or unconsciously lead to muddy and ungainly effects. A far better reference is the triangle of Figure 1. Here (value aside) it will be noted that tints have little in common with shades—unless given sequence through tones (as in chroma scales).

Because the value of a color will shift with changes in illumination intensity, it hardly seems logical to advise great respect for it. Yet one frequently is told that colors harmonize when their values are carefully related. Thus a color of value 3 supposedly will look well with a color of value 5 and a color of value 7. (See Figure 8 on page 24.)

While dim light may raise havoc with such balance, the worst part of this type of reasoning is that it encourages one to defy good psychological and esthetic order for a strictly relative law. It is not difficult to visualize what will happen when one begins to add small touches of black to some colors and small touches of white to others for the sake of bringing their values into some arbitrary alignment. He may collide with the natural order of color expressed in the Color Triangle of Figure 1. In order to accomplish one objective—value, which lacks stability—wholly normal and appealing concords may be destroyed.

Value should be studied by all means. But it should not be glorified out of proportion to its humble virtues. The writer therefore considers the Ostwald system—which is based on qualities of whiteness, grayness or blackness—more natural in organization than the Munsell system, which is built largely on brightness values since they are likely to be unstable under different intensities of illumination.

Refer back to Figure 8 in which a gray scale is illustrated. Now consider the following few elementary principles.

In addition to differences in hue (red, yellow, blue, etc.), and differences in chroma (weak, intense), the human eye will be found sensitive to differences in value or

As above, the Munsell color system scales its pure
hues toward grays of the same value — in horizontal
rows. As below, the Ostwald system scales its pure
hues toward a common gray. The latter arrange-
ment is more natural, for qualities of "whiteness,"
"blackness" or "grayness" are given precedence over
the less stable quality of value.

lightness. Simple balance is achieved where the steps from one value to another are fairly well related. Values 1-5-9 are of a primary order. Values 3-5-7 are also pleasing and in lesser contrast. Where value 5 is made the center point, perhaps the greatest beauty is achieved. This is the contention of many systems of color and holds more or less true where the middle-value is kept on the light side (a reflectance of about 25 per cent).

Now refer to Figure 14. Where values are not well related, colors close to each other in lightness or darkness will tend to cling together. Thus the center circle in one case appears large, and in the other it appears small. Through this observation one may readily appreciate that value (or weight) in color will largely control the appearance of shapes, forms and designs. The gestalt psychologist has studied this phenomenon and included it in the so-called "figure-ground" illusion. To the left in Figure 14 (A), the light gray disk associates itself with the background, and the central black disk becomes a relatively small figure. To the right (B), the deep gray disk associates itself with the figure and makes it appear large at the expense of the background.

In formal color harmony, however, value holds its greatest significance when considering the importance of proper and orderly sequence. In Figure 13 a white, a middle-gray and a black are arranged in six different sequences. Where the order is straightforward, 1-2-3, or 3-2-1, the eye finds greatest delight. Sequences A and B, therefore, will probably be found superior to all others. They follow a wholly natural and normal order. The other sequences are more jerky and awkward and introduce conflict.

The same beauty of sequence applies to other arrangements of color and color forms. Pure color-tint-white combine best when the tint form appears to lie about midway in color purity between the full hue and the neutral white. Pure color-shade-black; pure color-tone-gray; or tint-tone-shade (chroma scale), likewise present an excellent appearance when the central form seems to lie visually halfway between its two end forms —and when the relationship of one form to another is in a natural sequence.

To respect this latter principle, a pure color may be placed within a tint on a white ground for a highly satisfactory beauty. A pure color may be placed within a shade on a black ground. A pure color may be placed within a tone on a gray ground. A tint may

Figure 13. A study of sequences in value.

44

be placed within a tone on a shaded ground (chroma scale). These effects, using red, are illustrated on pages 38 and 39. In every such instance the natural order of the Color Triangle (Figure 1) has been regarded.

It is entirely possible, of course, to achieve good sequence and a proper balance of values at one and the same time. Yet between the two endeavors, it is more important to get sequences in order than to be unduly concerned with values. As illustrated on page 43, there are two ways in which colors may be scaled—first in straight horizontal rows toward a neutral gray of the same value (like Munsell), or in sequences that scale toward a common gray tone (like Ostwald). Both will have concordance, but the latter arrangement will be truer to the nature of color perception as expressed in the Color Triangle of Figure 1.

Experiments

Experiments in color value and color sequence should be performed in an elementary way. Using Figure 10 as a guide, the artist may work out a simple design and arrange its elements in different order.

Combinations of neutral gray should be tried first. After this, additional studies may be made with different forms of the same pure hue. Designs may be worked out with pure hue-tint-white, with pure hue-shade-black, with pure hue-tone-gray, with tint-tone-shade. An effort should be made to see that intermediate color forms visually lie midway between their end forms.

If desired, the artist may attempt color combinations involving two or more different hues—an effort that anticipates the next few chapters.

A B

Figure 14. Close values of color tend to cling together and affect apparent size and form.

10. Analogous Harmonies

When the problem involves the harmonious arrangement of different hues, broad principles rather than strict rules should by all means be considered. Laws of color harmony should not place severe restrictions on personal taste, nor interfere with creative impulses.

In this and following chapters the author wishes to take an extremely liberal viewpoint. No orthodox proposals will be made. There will be an attempt to acquaint the artist with various general dimensions of color harmony and then to set him free on his own course. A guide is helpful in conducting a traveler through strange lands. Yet the guide will spoil a lot of fun if he insists upon telling the traveler what he should and should not enjoy.

In a broad sense color harmony may take advantage of several phenomena:
— The neat order of the Color Triangle (Figure 1).
— The inherent beauty of tint scales, shade scales, tone scales, uniform chroma scales, and color schemes based upon their sequences.
— Godlove's principle.
— The desirability of good balance in value.
— The appeal assured where intermediate color forms appear to lie midway between their two end forms.

Although the harmonious combination of different *hues* may seem to involve complications, the problem is really a simple one if the reader will keep these things in mind as he continues his studies in this book.

To encourage the reader, let me set forth a few elementary facts:

All pure colors will usually harmonize with white and black. Here the matter of value requires little if any attention.

Tints of all kinds will harmonize with white.

Shades of all kinds will harmonize with black.

Tones of all kinds will harmonize with gray.

It would be difficult to go wrong in any of the above arrangements, regardless of what hues are put together and what values they may have.

Yet where some element of personality is desired in the matter of *hue*, the artist will more than likely have definite preferences. He may like delicate arrangements or impulsive ones. His feeling may be for analogy or contrast, for subtlety or boldness. To bring out his own instincts for color he should grow familiar with color organization in general and the various paths that lead to harmonious sequences.

Numerous psychological investigations have shown that most people find pleasure in color combinations based on (a) analogous hues, and (b) opposite hues. Combinations of intermediate hues are deemed less attractive.

Study Figure 15. Analogous hues are those which lie next to each other on the color circle. They are termed adjacents. The adjacents of yellow are yellow-orange and yellow-green; the adjacents of red are red-orange and magenta; the adjacents of blue are turquoise and violet, etc.

Such analogous schemes do not, of course, have to be accepted too literally; the distinctions do not require technical accuracy. In nature, analogous concords are commonly found. The highlights and shadows of a rose will scale from red-orange through red to red-violet. An orange nasturtium will scale from orange at the edge of the petal to yellow, to yellow-green. Iridescence in a peacock feather and on the wings of some insects will show glints of green, blue and violet. Water may appear greenish, bluish and violet at different depths. The hues of autumn may run analogously through green, yellow-green, yellow, orange, red, purple.

Analogous color schemes have an emotional quality in that they usually give pref-

Using one color only, any number of appealing and well organized color sequences may be arranged. The eye appreciates and enjoys good order. While such order may be disregarded at the artist's discretion, he should at least be conscious that natural laws do exist.

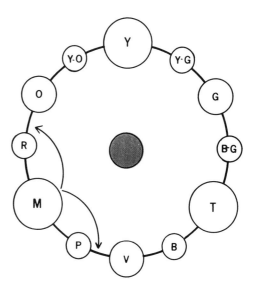

Figure 15. Plotting analogous harmonies.

47

erence either to the warm or cool region of the spectrum. For this reason they are inclined to be soft, mellow and to inspire a precise mood—active where the arrangement is warm, passive where it is cool.

As with any selection of hues, the artist should always bear in mind that the preferred colors of most people are blue, red and green. Hence the appeal of adjacents in one part of the color circle will not necessarily equal the appeal of adjacents found in other parts. Color systems are at fault when they imply that a particular rule holds true regardless of the way it is plotted on the color circle.

For frank attraction, adjacent combinations based on blue, red and green may prove best. More subtlety and "elegance," however, may follow combinations based on other intermediate colors such as orange, violet, yellow-green, blue-green, etc.

Adjacent schemes may be composed not only of pure colors but of tints, shades and tones. When modified color forms are involved the artist may well remember the natural order of the Color Triangle (Figure 1) and the principles already discussed.

The illustrations on page 50 show a few adjacent or analogous color schemes. These are identified as Palettes, and Munsell designations for them (as used in the original art work) will be found at the end of this book.

Palette I uses green with its adjacents yellow-green and blue-green for a cool effect.

Palette II combines red with pink and orange for a warm effect.

In Palette III violet and purple are used.

As the reader will note, not only has good traditional order been respected as to the sequence of hues, but due attention has been paid to the natural arrangement of color forms as expressed in Figure 1.

This exercise of control over color is quite simply accomplished once fundamentals are grasped. While it may not constitute great art or originality, at least it shows considerable skill. It is like good technique in a musician, good vocabulary in a writer, good stage presence in an actor—necessary bases for creative effort.

Experiments

To study the beauty of analogous color schemes the artist should work out numerous combinations. One design may be executed using pure adjacent hues on white.

Other series may then be tried using adjacent tints on white, adjacent shades on black, adjacent tones on gray.

The final problem may consist of a harmonious arrangement of various forms. Here combinations may be based on tint scales, shade scales, tone scales, chroma scales. For example, pure red may be combined with tints of orange and magenta on white. Pure yellow may be combined with shades of orange (brown) and yellow-green (olive) on black. Pure blue may be combined with tones of turquoise and violet on gray. A tint of orange, a tone of red, and a shade of magenta (chroma scale) may be arranged on a gray ground.

11. Complementary Harmonies

To repeat, it is natural for most people to find pleasure in harmonies based on analogy and on extreme contrast. The choice of adjacents (for analogy) has been described in the previous chapter. Here the effect is largely emotional because it results in color schemes which are predominantly warm or cool in feeling.

Where the principle is based on the use of complements, or opposites, the result is more startling and has a compelling visual quality.

Opposite colors are those which lie across from each other on the color circle: red and blue-green, yellow and violet, orange and turquoise, etc. (See Figure 16.) Again, the selection does not have to be too strict. Red, for example, will be ideally complemented by green, by blue-green or by turquoise: one pair will have no "scientific" advantage over another. Personal feeling would be as good a guide as any—as long as the hues are far removed from each other visually.

In this principle of contrast the selection may be of simple order: red with blue-green, yellow with violet, etc. For more variety it may also be based on the use of the so-called split-complement. Here, a key hue is com-bined with the two that lie adjacent to its opposite: red with green and turquoise; yellow with purple and blue; blue with orange and yellow, etc.

In Palette IV on page 50, green and yellow-green have been combined with a shade of warm brown. These may not be exact complements, but they appear harmonious. The over-all effect is warm and favors the hues of the upper part of the color circle.

In Palette V on page 50, two direct complements, orange and turquoise are used together. Note the contrasting effect as compared with the other color schemes on this page. The orange-turquoise pair balances warmth against coolness, and the eye is treated to a fairly sparkling result.

In Palette VI on page 51, yellow is used with its split-complement, purple and violet. Again the effect is visual in that the warm luminosity of yellow is set against the cool and retiring qualities of violet.

Nature makes frequent use of opposite colors. Blue or violet wild flowers generally have orange or yellow centers. Blue on butterflies or birds is often accompanied by spots of orange. Red and purple flowers with green foliage, clear blue sky against golden rock formations—these are further harmonies of nature which have delighted mankind through the centuries.

A visual rather than emotional quality for opposites is regulated by the fact that any precise mood associated with warm colors such as red, orange or yellow may be cancelled by the conflicting emotional quali-

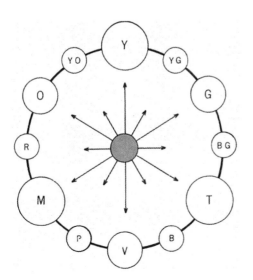

Figure 16. Plotting color schemes based on opposites.

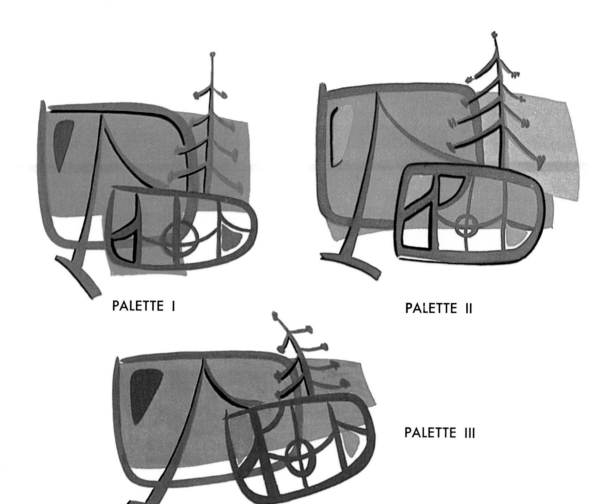

PALETTE I

PALETTE II

PALETTE III

PALETTE IV

PALETTE V

ties of cool colors such as green, blue or violet. While the result may be highly startling to the eye, it also may lack a consistent character.

Some color theorists have set forth the rule that schemes of opposites are most pleasing when they represent true visual complements and when their areas in a design cancel into neutral gray if spun in like proportions on a color wheel. By this measurement red is supposed to harmonize best with blue-green when the area of blue-green is relatively three or four times greater than the area of red. (Because red is a color of stronger chroma than blue-green, less of it is required to form gray on a color wheel.)

While the rule suggests a definite quantitative measurement of harmony, it unfortunately is no sure proof of beauty. To begin with, average taste may favor green or turquoise as better complements for red than blue-green. Again, most persons are inclined to favor schemes in which their preferred colors are held dominant in area. Thus anyone who really liked red would be disappointed if the red area in a design were balanced against three or four times more area for blue-green. In fact, such an arrangement would no longer be a red color scheme.

As to the element of area in working out color combinations, it is perhaps safe to state that strong pure hues look best when confined to smaller areas and when they are surrounded by larger complementary areas in softer chromas (tints, shades or tones). Red and turquoise are impulsive and may look well in a poster or package. But for more refined works of art, the red may be given greater character if it is contrasted against weaker shades or tones of turquoise, green or blue-green.

Warm colors, however, do not have to be invariably accompanied by larger proportions of cool colors. Red for example may command a design and be featured through the use of *small* touches of green or blue.

These color schemes are based on sound traditions of color which have been known over many years. They represent good order and seem to follow natural laws of arrangement. Shown are various analogous schemes, complements and split-complements.

PALETTE VI

In experimenting with complements, a few practical facts may be remembered.

Warm colors such as red and orange will tend to be aggressive and advancing. They may make better feature hues than background hues.

Cool hues such as blue and violet, being passive, make ideal backgrounds.

Modified color forms such as tints, shades, tones will also tend to retire. Lightness, however, will usually hold ascendancy over darkness. The most subdued and passive of forms is the tone—and a bluish or violet tone will appear more distant and atmospheric than any other.

Strong colors look best when confined to relatively small areas. This device, however, is not to be accepted too strictly.

While charts and diagrams serve a useful purpose in the pleasing arrangement of color schemes, there is really no substitute for good taste and keen observation on the part of the designer or artist. He must always add something of his personality and not let it be subservient to any formalized conceptions of beauty.

Experiments

As recommended for analogous schemes, the artist may experiment with numerous combinations. One design may be carried out using pure hues on white—direct complements as well as split-complements.

Other combinations may then be tried using tints on white, shades on black, tones on gray.

Finally, advanced harmonies may be attempted in which the color forms as well as the hues are combined in appealing order. Schemes based on primary colors—red, green, yellow, blue—will be found to have a frank and striking quality. Schemes based on secondary hues—yellow-green, purple, orange, blue-green, etc. may lack such primitive quality and may, for this reason, be considered more refined.

12. Balanced Harmonies

Analogous harmonies involve the use of closely related hues. Complements and split-complements involve the use of hues having opposite relationships. In a third principle —balance—the whole of the color circle is exploited. Here the strategy is to take a series of colors (three or four in number) which are more or less uniformly removed from each other on the color circle. Balanced harmonies offer a fuller diet of the spectrum.

One primary triad of balanced colors will be found in magenta, yellow and turquoise. A secondary triad will be found in orange, green and violet. On the color circle two further triads will be noted: red, yellow-green and blue; purple, yellow-orange and blue-green. (See Figure 17.)

Each of these triads will be found to have a unique beauty. Magenta, yellow, turquoise is the most primitive. Purple, yellow-orange and blue-green is perhaps the most subtle and refined. The triad of orange, green and violet is likewise of a delicate order. A startling and somewhat gaudy triad is that comprised of red, yellow-green and blue.

Harmonies based on four colors (tetrads) may also be designed. Hues three steps re-moved on the color circle may be chosen. There are three such tetrads on the color circle—red, yellow, blue-green and violet; magenta, yellow-orange, green and blue; and purple, orange, yellow-green and turquoise.

Once again, any selection of colors should never be too orthodox. Good expression calls for taste and feeling rather than an impersonal adherence to fixed conventions. In the principle of balance, the eye will see colors which more or less touch all regions of the spectrum—boldly among primary hues, or gently among secondary hues. This perhaps is all that needs to be remembered.

Balanced color schemes are commonly found in nature. The sunset and the rainbow are complete spectrums in themselves. Lichens and mosses will frequently show glints of intermediate hues, yellow-greens, blue-greens, red-violets, blue-violets. The opal is another such example. The colors of spring present balanced harmonies of tints. Summer presents balanced harmonies of pure hues. Fall presents balanced harmonies of shades, while winter presents balanced harmonies of dull grayish tones.

Where the whole of the color circle is to be considered in the development of a color scheme, artistic resourcefulness will be put to a real test. The artist may have to keep many factors in mind and to exert some measure of control and coordination over all of them. In pictorial and abstract art, in decoration and design, the balanced scheme is extensively favored and has universal ap-

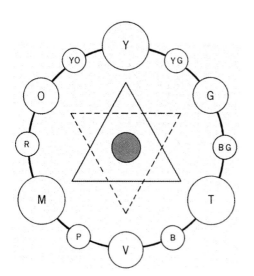

Figure 17. Triad Color Harmonies.

PALETTE VII

PALETTE VIII

peal. To simplify expression and develop a sensible organization of ideas the following principles may be considered:

The purer and warmer colors are best confined to feature parts of a drawing or design. Conversely, the cooler hues may look best in the background.

Where many colors are utilized, the primary order of forms (pure color, white, black) or the secondary order (tint, shade, tone) may offer fullest possibilities. However, beautiful concords are to be built upon tint scales, shade scales, tone scales and chroma scales—letting the sequences follow good psychological order and the sound relationships of value implied by Godlove's principle.

It is good practice and training to make a few mental notations before actually mixing pigments. The artist should be able to visualize his effects, to plan them in advance rather than rely upon trial-and-error methods. Imagination and initiative may thus be developed. Nature may be consulted, if desired, as the basis of creative expression. Art, however, must always be personal to human feeling.

Refer to the color schemes on pages 54 and 55. Palette VII shows a triad of red, yellow and turquoise blue. The artist has not precisely followed the order of Figure 17, nor has it been necessary for him to do so. Once a simple concept of color is planned, minor liberties may be taken with it. If the artist is too orthodox, individuality will hardly be achieved.

In Palette VIII on page 54, orange, green and violet are combined. This follows an ac-

Illustrations show an elementary triad (Palette VII), a triad of secondaries (Palette VIII), and a tetrad combining the basic psychological primaries, red, yellow, green, blue (Palette IX). The colors of the spectrum are full of personality to which the artist may add his own individual interpretation, thus making creative originality possible.

PALETTE IX

curate plotting of Figure 17. If these two palettes are compared (VII and VIII), quite different visual and emotional qualities will perhaps be noted.

Primary colors have a simple, basic quality, while intermediate colors are more refined. Why is this? It probably can be explained by the fact that the eye (and brain) are so organized as to see red, yellow, green, blue as primary. Each is unique in sensation. The four do not resemble each other. Yet, orange and violet (as in Palette VII) seem to have no such individuality. Certainly in looking at orange, a person will be conscious of a blend of red and yellow, and in looking at violet he will see a blend of red and blue. But who can see anything but red in red and blue in blue?

An appreciation of such subtleties is of great value to the artist. If he wishes to appeal frankly to masses of people at large, he would do well to arrange primaries. If he wishes to be more sophisticated or exclusive, he may resort to the use of secondaries. The same would apply to other color forms, tints, shades, tones. White and black are quite direct in impact, while muted tones are obviously refined.

In Palette IX on page 55, simple red, yellow, green, and blue are brought together. Such an arrangement seems to have universal qualities of beauty.

Experiments

Experimental color schemes should be worked out with triads and tetrads. Initial schemes should comprise pure hues with white and black. The study may then be extended to combinations of tint, shade, tone, gray.

At least one fairly elaborate scheme should be designed to contain all the seven forms of Figure 1. Excellent subjects would be an abstract conception of a bowl of flowers or a combination of free-flowing non-objective forms. To tie design elements and areas together, the units may be keyed with touches of pure hue, highlighted with tints and shaded with shades. Tones may then be blended in the background for softness and a feeling of distance. A wholly orderly and beautiful color scheme may thus be composed, even though it may contain dozens of hue variations.

13. Dominant Harmonies

The principles of color harmony described in the last few chapters have been well-known for many years. Although, they are not new, they have been brought to a simpler basis. How is the art of color to work progressively from them, to establish new expressions that depart from old conventions?

Many systems of color have sought the answer by trying to develop complex arrangements of hue based on orderly and sometimes mathematical relationships of color notes and scales. Color schemes are "proved" beautiful through the laborious process of spinning disks, tracing elliptical paths through color solids and the like.

In my personal experience, most such trying endeavors have not been worth the effort. Not only do they have rare application, but they tend to clutter up the mind with technical procedures which follow a dull and monotonous routine. Anything creative is likely to be tied down with strings like the mighty Gulliver. After all, if a group of artists were all to follow the same rules, where would individuality come in? It may be, of course, that each might have a different concept of design or composition, but why should the attitude toward color be formalized? While I strongly favor good academic training, it should be a means toward an end and not an end in itself. Its purpose is to provide competence and knowledge and then to let the artist progress freely on his own.

Thus too much emphasis on conformance to arbitrary principles may be irrelevant. The artist, for no good reason, may devote himself to external things which may be without personal value once he endeavors to turn his education to creative ends.

The study of this particular chapter—dominant harmonies—has a double significance. It rounds out the chapters so far presented in this section, and serves as an introduction to the chapters to come and to a new series of principles encompassed in the term Perceptionism. In a dominant harmony, one hue is glorified as a feature color and made to influence all others within a given design or drawing. This may be accomplished in one of two ways:

A. By using a uniform transparent layer of one color over a given selection of other colors. This has been done in the illustrations on pages 58 and 59.

B. By adding a portion of one particular pigment to all other pigments mixed in the execution of a color scheme.

In either case, the key hue is held dominant. Harmony is assured in that all colors are brought into consistent relationship.

The illustrations on pages 58 and 59 are based on Palette IX (see page 55), which is comprised of elementary red, yellow, green, and blue. They were executed in tempera. Using masks, the artist then sprayed transparent layers of blue, red, green and yellow, as shown. This is a convenient way of harmonizing colors. However, for truly convincing effects of transparency, refer to Chapter 22.

Dominant harmonies hold much appeal. Inasmuch as most people are likely to have

preferred hues (red, blue, or green), their likes may be satisfied by a color combination in which their color preference is in full command. The mellow quality of color found in many paintings of the old masters, the startling beauty of a sunset, of Indian summer, of moonlight, all represent dominant harmonies in which one color seems to pervade the scene. Beauty in color here finds one of its most eloquent expressions.

Dominant harmonies have much in common with qualities of light and illumination. They also introduce a distinction between color *schemes* and color *effects*. Let me try to make this clear, for the chapters which are to follow are rather new to the art of color and express a viewpoint not to be found in many books.

In a color *scheme*, the chief end is to assemble a series of colors which will suggest harmonious order and appear concordant to the eye. The process may be likened to a game of cards in which numbers, suits, colors may be arranged in various sequences. Personal judgment and skill (plus chance) are important. However, the rules have been set, and it is the job of the player to see how well he can manage them.

In a color *effect*, however, the deck of cards is set aside. The individual elements in the color scheme lose their importance and become secondary. Now the artist or designer is concerned with different appeals entirely, with thoughts, ideas and *effects* that automatically establish for him the hue, form and quality of all colors that will enter into his thinking.

He is not concerned with colors as mere colors, or combinations of colors, but as *effects* that transcend and overflow details—luminosity, luster, iridescence, illusions of texture, space and solidity. He may think in terms of human perception. His viewpoint is broadened, his imagination given new impetus. He is free to stride forward toward new horizons.

Dominant harmonies are simply effected by putting transparent layers of colors over various assortments of hues, as shown here. Almost any color scheme, gaudy or otherwise, will be brought into pleasing visual relationship. Such "atmospheric" qualities are quite apparent in many famous paintings of the past.

Experiments

To experiment with the principle of dominant harmony, the artist may try one of two techniques.

First, a conventional harmony may be worked out in a simple abstract design or drawing, preferably using clear water colors. Over this a thin wash of transparent color should be applied. The best colors to use for the wash are yellow, light red, light blue, light green.

Second, a series of harmonious colors should be mixed in separate jars or pans. Tempera is ideal for this experiment. Then a uniform quantity of one basic hue should be added to each mixture—and a design or drawing executed.

Harmony will be quite automatic. Analogous colors will remain fairly rich. Complementary colors, however, will be grayed. The dominant color will pull all elements into accord.

The artist should realize, however, that the action of one pigment upon another is not the same as the action of colored *light* upon pigments. True illumination effects may thus not be achieved.

PART II

14. New Horizons – Perceptionism

The art of color owes a great debt to the psychologist for his revealing studies of the nature of human perception. For to the psychologist, color is sensation and highly personal, even though the experience of it may depend on light energy. Color, in a word, is thus an interpretation of eye and mind, an inner reaction which has little to do with physics or chemistry.

Colors, for example, may be produced in a wide variety of ways. The rainbow, the luster of an opal, a drop of oil on water, iridescence in a peacock feather or the wing of a butterfly—these may be caused by refraction, dispersion, diffraction, interference, polarization of light waves, rather than by pigments or dyes which absorb and reflect light rays differently. Many colors found in birds such as the bluejay may be formed by small air bubbles in the horny mass of the feathers. The magic may be such that rays of sunlight are scattered by suspended particles or split apart into their component hues as they pass through screen-like or crystal-like surfaces or thin films. The blue of a flower may appear quite like the blue of a feather or the blue of a child's eyes—even though the color in each of these instances may be produced in a different way.

These observations should impress the fact that the physics of color and the psychology of color are curiously independent.

As far as the art of color is concerned, greatest profit will follow a study of subjective, rather than objective, factors.

There are in human experience many interpretations of color. For example, place a square of smooth colored paper on the top of a desk or table. Such a color will appear flat and definitely localized. Now take a black card with a small opening cut in its center, hold it several inches from the eye and gaze at the underneath colored paper. Now the color lying on the desk will appear more filmy in aspect. It will not be flat but will seem to fill the space between the card and the desk.

To those who seek new dimensions for color, let me recommend a study of phenomena such as the following:

A given color, such as red, may have a large number of different appearances.

— It may be filmy and atmospheric like a patch of crimson sky at sunset.
— It may have volume to it like a glass of red wine.
— It may be transparent like a piece of cellophane.
— It may be luminous like a stop light or a lantern.
— It may be dull like a piece of suede.
— It may be lustrous like a piece of silk.
— It may be metallic like a Christmas tree ornament.

— It may be iridescent like the gleam of an opal.

It is wholly conceivable that all such red colors could be made to match each other and thus be identical as far as instrumental measurements and physics were concerned. Yet in personal experience, each of the reds would be different, each would have a beauty of its own, an *effect* that would be unique. (Also see Chapter 22.)

Obviously, color harmony of the conventional sort becomes a somewhat prosaic study when one gives his thoughts more latitude and freedom. Red is no longer merely red. The question as to what other colors harmonize best with red becomes academic. What kind of a red? And will a red surface color have the same appeal as a red film color, a red volume color, a transparent red, a luminous red, a dull red, a lustrous red, a metallic red, or an iridescent red?

Perception is all-important. It is for this reason that the color principles to be described and illustrated in the pages that follow are encompassed in the term Perceptionism. A person does not merely see what literally is before him. On the contrary, he participates in the art of seeing and adds much on his own. Refer, for example, to Figure 18. Does a person see an urn or two faces? There is but one retinal image, and yet perception does strange things to it.

In the realm of color, similar phenomena occur. David Katz wrote, "The way in which we see the color of a surface is in large measure independent of the intensity and wave-length of the light it reflects." As will be stated again, white is not white merely because it reflects a lot of light, nor is black

Figure 18. The magic of perception. Do you see an urn or two faces?

PALETTE X

62

black merely because it reflects little light. As a matter of fact, it is possible to shower a black surface with intense light so that it is actually brighter than a white surface in shadow. Yet the black will persist in looking black and the white will persist in looking white.

Perceptionism as an advanced art of color is built largely upon such visual phenomena. And it has much to do with the subtleties of perception, of impressions of illumination, and of the ways in which colors take on unusual qualities when handled expertly.

After all, there may be little if any physical difference (in light energy or wave length) between surface or film colors, luminous or lustrous ones. Such modes of appearance or effects usually depend on human interpretation—which is usually built upon clues offered by the background or environment in which colors appear. Therefore if the artist knows what he is about, he may create virtually any result he wishes. He may transcend his medium (paints) and, through the wonders of perception, treat the eye to new and original beauty.

Experiments

As suggested in this chapter, the artist should collect examples showing the different visual appearances of a color. Using the same basic hue, such a collection should include examples of surface color, volume color (such as a vial of dye), transparency, luminosity, iridescence, cotton, velvet, silk, metal—and any other unique textures which come to mind. These are what science calls modes of appearance for color.

These effects of colored illumination are described in Chapter 19, "Chromatic Light." (pp. 85 ff.) They show a normal array of colors showered with chromatic light — red in one instance, yellow in the other. Such illusion is a stimulus to imagination and creative originality and may be adapted to almost any art form. Other illustrations of chromatic light effects appear on pages 66, 67, 86, and 87.

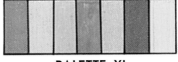

PALETTE XI

15. The Law of Field Size

Differences of texture and appearance in color are relatively easy to understand. They represent plus qualities, effects which may be developed into new principles for the glorification of the art of color.

The substance of this chapter, however, may be somewhat more complex. Yet if the reader will free his mind of past conventions, he will find the discussion understandable—and refreshing as a departure from the usual course of color study.

The artist today needs to add a few new terms to his vocabulary if he is to comprehend new dimensions in color expression. One of these is the Law of Field Size, which also might be called the Law of Field Proportion. (This book generally reduces the term merely to *field*.) Here is what is meant:

One has a knowledge of areas, objects and things in the world through illumination. Conversely, one gains indications of illumination through the appearance of things within the field of view. If most things seen are bright, then bright illumination is experienced. (The field is light.) If most things seen are dim, then dim illumination is experienced. (The field is dark.) If there is softness and grayness, the experience may be one of mist or distance. (The field is grayish.)

This is normal to human perception. However, if illumination is *implied* in a drawing or work of art, the eye may be treated to unusual effects. To anticipate coming chapters, a dark field allows for lustrous effects; a grayish field allows for iridescent effects;

a tinted field allows for effects of chromatic light or chromatic mist.

Consider the following commonplace experience. A piece of white material out in the sun may be showered with as much as 10,000 footcandles of light energy. If this white material is taken indoors and placed in a bureau drawer it will still appear white, even though the light intensity may now be less than one footcandle.

Colors in bright and dim light, however, will be affected in "strength" or what is called pronouncedness. This is another term to remember. A white surface, for example, will appear to have the same value under various lighting conditions. However under bright light it will be "sharper," "harder," or more pronounced. Under dim light it will appear "softer," or less pronounced. The same thing takes place with colors; they are more pronounced under bright light than

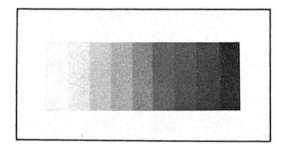

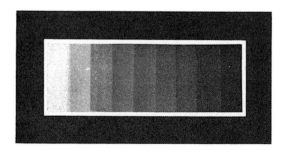

Figure 19. The appearance of a gray scale under bright and dim light.

Figure 20. An impression of normal illumination.

under dim light. Refer to Figure 19. Under normal light a gray scale will be seen in all its subtle gradations, the white having high pronouncedness. As illumination is dimmed, deeper values will tend to blend together and be confused. The eye will now distinguish but two major differences in value: a narrow band of white having low pronouncedness, and a wide band of deep or blackish values. Intermediate steps will be found to have melted together.

Now to apply the Law of Field Size or Proportion, consider the following.

— Where the major field of a drawing or design is in fairly light values and pure and clean hues, bright illumination will be implied—*regardless of the actual lighting intensity that may exist when the drawing or design is executed or viewed.*

— Where the major field is deep and where colors are slightly blackish or grayish, dim illumination will be implied.

These represent color *effects* that are to-

Figure 21. An impression of dim illumination.

Figure 22. An impression of atmosphere or mist.

PALETTE XII

tally aside from the usual conception of color *schemes*.

Expert control of the field on a drawing will enable an artist to create truly unique and startling color expressions. The major field of a drawing or design establishes a certain illumination quality—bright, dark, grayish. And from this established quality the artist is able to make his incidental touches of hue do surprising things—to appear lustrous, iridescent, luminous and the like. Although illusion is involved, the ends of personal creation are beautifully served.

Figures 20, 21 and 22, in black and white, represent practical experiments in which a quality of illumination transcends a mere arrangement of gray values.

In Figure 20 the design is seen as normally illuminated. A number of neatly stepped values may be distinguished.

In Figure 21 one perceives a feeling of dim light—even though the values here also scale from white to deep gray. (In this

sketch, however, the field has been kept deep in key.)

In Figure 22 there is an appearance of atmosphere or mist. There is more indication of space and filminess. Here the field is soft and mellow in character.

Illumination creates and destroys objects and space, just as it is needed to convey visual impressions to the eye and brain. The ability to see color, structure, form, texture, and the like, naturally depends on light. At the same time, the quality of illumination is judged by the appearance of things in the field of view.

Thus, one knows if it is a sunny or cloudy day without having to look up at the sun or sky. He judges illumination by the way the world looks. However, whether the day is bright or dim, the colors of familiar things remain quite stable. That is, white doesn't turn gray when a shadow passes over the sun. Nor would a gray surface turn white if sunlight struck it. Here is a big difference between eyes and cameras. With a camera, an overexposure of a gray surface would result in a white photographic print, and an underexposure of a white surface would result in gray. In vision, however, there are no such overexposures or underexposures. The world persists in remaining normal, regardless of shifts in illumination.

Examples of the effect of green and blue illumination, described in Chapter 19, "Chromatic Light." (pp. 85 ff.) Chromatic light effects are quite limited in nature — pink, orange, yellow, pale blue. The artist, however, may create and establish them at will. Although "unnatural," they are fully understood in human perception. Other illustrations of chromatic light effects appear on pages 62, 63, 86, and 87.

PALETTE XIII

If so much depends on illumination, the artist may profit from an understanding of its role in human perception. In Perceptionism, illumination qualities are deliberately controlled. And where they are so controlled, new color expressions become possible.

If the field of a drawing is carefully adjusted, shaded areas (blackish) which imply dim light may be used as a foil to create unusually lustrous effects. A grayed area may be used to create iridescent effects. The artist may, in any medium, free himself from technical limitations and actually work with perception itself.

Whether the effort of creative expression be pictorial or abstract, realistic or non-objective, a painting or a design, the color scheme may readily be converted to a color effect. The artist may think and plan not only in terms of combinations of pure hues, tints, shades, tones, adjacents, complements, etc., but of an over-all and pervading beauty that finds its secret in the general character of the field or background. He may distract the eye from the fact that it is actually looking at pigments, paints or dyes and convince it that it sees other textures and qualities altogether.

Experiments

Using gray values only, experiments should be made with controlled fields. The artist may refer to Figures 20, 21 and 22 for guidance. His subject may be of a realistic nature or in the form of an abstract design.

Many values from light to dark, well distributed, will imply normal illumination.

Where the larger field of the drawing or design is in deep key (but not actually black) dim illumination will be suggested. Here some incidental touches of white or pale gray should be included.

Where the larger field is in medium key, soft and lacking in detail, an atmospheric or even luminous effect may be produced. This control of the field or environment may then provide settings in which truly remarkable color effects may be achieved.

Figure 23. An impression of luster.

16. The Lustrous Effect

Many of the great artists of history have understood Perceptionism and the Law of Field Size or Proportion—perhaps not in a scientific way but through an innate genius. The luminous flesh tones achieved by Rembrandt, the illusions of atmospheric twilight achieved by Inness, owe their beauty to the fact that *the larger area or field of the canvas has keyed the smaller areas and has given them a dramatic glory.*

A lustrous effect in color is to be accomplished in a simple way, once an altogether logical and evident principle is followed. I begin with it in this story of the new vision because it is quite easy to master. The artist must bear in mind, however, that he is to abandon any conventional notions about color schemes. He is no longer to work with an assemblage of little parts arranged in some agreeable order. To the contrary, his drawing or design is to represent one consistent effort in which all details are carefully integrated. All incidental parts must support this effect and be subservient to it. He must use the larger area of his field to dramatize and feature the smaller touches. He is to convey a unique and striking visual impression. This he will do by holding his colors under careful control, grading them and manipulating them in ways that will delight the eye with remarkable novelty and beauty.

The quality of luster in color is somewhat psychological. What is the difference visually between a piece of red cotton and a piece of red silk? Silk appears shinier and richer. It is, in a word, brighter than a red pigment of medium value. Many artists in the past have quite successfully achieved the effect of luster. Some have resorted to mechanical tricks. However, the artist's job is perhaps not to use metal to portray metal, or silk to portray silk, but to have control over his palette and by shrewd observation and resourcefulness suggest the effect without being literal about it.

If the larger area of a drawing is composed of slightly shaded hues, and if such suppression is fairly uniform, the eye will sense that the colors seen are natural enough but in moderately dim illumination. Here the field will be on the dark side. Now if incidental touches of pure and intense color are added, they will appear exceptionally brilliant in comparison with the softer quality of the larger area. They will be brighter than normal—hence lustrous. The effect, of course, is a visual one. The paints themselves do not have to be shiny. Luster is seen as an illusion; a generally dark field is cleverly applied to make colors of medium value seem endowed with remarkably vivid chroma and brightness.

Refer to Figure 23 on page 68 in which the principle is illustrated in black and white. The effect of luster is dependent upon black contrast. Various methods may be used to simulate it. For example, prepare a drawing or design having small elements and color it with pure tempera paints such as bright red, yellow, green, turquoise. The background may be white or light gray. With an air-

PALETTE XIV

70

brush now coat the entire sheet uniformly with a thin layer of black. This will serve to imply a slightly reduced level of illumination over the entire composition. If small touches of the original pure hues are now replaced in the drawing, they will at once shine forth with striking purity and have a lustrous or metallic sheen to them.

A more impressive method is to work on a dark background such as black, navy, maroon, brown. Take a selection of pure tempera colors. The best ones to use would be a vermilion red, orange, yellow, vivid yellowish green and turquoise blue (avoid deep reds, blues and violet). Using black tempera, prepare a shade scale of each basic hue, having three or four steps from purity to black. By working from the deeper tone to the brighter and purer, paint a simple design. The larger area of the drawing will naturally be in the deep tones. Now work up the scale using the other shades. When the light pure tones are eventually added, *and every square inch of the background covered*, these clear touches should be extremely lustrous. They will appear to be far more brilliant than they actually are.

A very dramatic example of such luster, done in this fashion, will be found in Palette XIV on pages 70 and 71. The original was made in tempera and, of course, the reproduction is with ordinary printing inks. Yet note the almost fluorescent quality. An effect like this, while suitable enough for representational art, would be startling in nonobjective art; one rarely sees anything like it.

There are various types of luster seen by the eye, and each is visually unique. Silk differs from satin. Luster may be translucent like fine metallic cloth, or bold and sharp like solid, polished metal.

Luster fascinated the Old Masters. It was sometimes accomplished with thin glazes over white so that light would be brightly refracted or reflected. Some painters with literal minds put washes over metal foil. In the *chiaroscuro* style already mentioned—and perfected by da Vinci—the uniform chroma scale was invented and exploited. Texture became something of an obsession during the Renaissance, and metal buttons, gold crowns, the simulation of jewels, silk

Two illustrations of luster. Although the originals were done in tempera and the reproductions with conventional printing inks, note the unusual brilliance. Through careful control, the artist has succeeded in making his colors appear more intense than they actually are. He has glorified the role of human perception.

embroidery all were given detailed attention.

Yet luster does not have to be a mechanical trick. Rembrandt achieved it with thick layers of paint rather than transparent ones. Once the principle of luster is grasped as a visual and perceptual interpretation, it can be executed in any medium. Printed cotton, for example, or pile fabrics or carpeting can be made to glisten where the phenomenon is understood. Here luster may be put in the eye, so to speak, and doesn't have to be in the medium used.

Some luster, such as silk, has a feathery edge. Other luster, like metal, has sharp highlights and shadows. Incidentally, a lustrous surface or object may reflect "mirrored" highlights which may be in quite another color. However, the true luster of a red vase, for example, is rich and vivid. And if red (or any other color) is to be made lustrous, as in Palette XIV on page 70, its highlight (unless a mirrored one) must be pure. Pink would destroy the illusion. To achieve it, the major color of the object should be a suppressed red or maroon. Then a vermilion highlight will really shine!

Once the principle of luster is understood, certain refinements can be added. Complementary mixtures of paints (to avoid the use of black) can be employed. Also, lighter toned or shaded backgrounds can be selected. However, the greater area or field of a design will have a slightly shadowed or blackish appearance—to key the drawing and convince the eye that illumination is slightly dim. It is this visual device which intensifies the smaller areas of pure color and makes them remarkably brilliant.

Experiments

Carry out the experiments described in this chapter. Refer also to Palette XIV on page 70. Pictorial or abstract designs may be planned. The important point to remember is that a slightly uniform and dim illumination should seem to pervade the larger area of the field. Before the pure touches are added, the colors on the drawing should appear as fairly normal but as though uniformly thrown into shadow. Also remember that the lustrous effect will not as a rule be apparent until the background is entirely covered. Any areas, small or otherwise, which are allowed to remain white will interfere with the result. It is the uniformly suppressed background which, by comparison with the smaller touches of pure hue, assures success.

Figure 24. An impression of iridescence.

17. The Iridescent Effect

Uniform suppression of the field in shadow (blackness) is the secret of making smaller touches of pure color appear lustrous. To simulate the phenomenon of iridescence, as in mother-of-pearl, the opal, and the like, the uniform suppression must be in terms of a gray field. Here again Perceptionism is involved.

Appreciate, of course, that iridescence is an elusive thing. Iridescent colors in nature owe their existence to what the physicist terms diffraction (a type of interference), not to pigments. What happens is that the minute structural character of the surface splits a ray of light into its component parts and the eye sees various spectral hues separated from each other. This also accounts for the fact that iridescent materials tend to shift and change in hue when seen from different angles—surely a dynamic quality which seems to defy duplication in a static drawing or design.

None the less, the iridescent effect is to be attained through expert control of the field. The beauty of mother-of-pearl, the wings of butterflies, so appealing to everyone, can become part of creative expression and lead to new dimensions. Once again, the conventions of the past can be disregarded for more vital techniques and principles. The art of color can be shaken out of its lethargy. The artist and designer can find new inspirations, and the world at large can be treated to new and unprecedented color effects.

While the phenomenon of luster is best achieved by featuring the vividness of pure hues against black or rich deep shades, the effect of iridescence is softer and more refined and features the beauty of delicate tints, or so-called pastels against gray.

In accordance with the Law of Field Size or Proportion, the major area of the drawing or design must be predominantly grayish in tone. This will serve to give the eye an illusion of mistiness and uniformly reduced chroma. With this softness as a key, incidental touches of pure hues or clear tints will then take on a fascinating glint and appear to shine as though endowed with an inherent luminosity—a quality that will seem quite apart from that of the paint itself. The effect, in other words, will transcend the materials used to execute it.

Various methods are available to the artist. Let him first study the black and white example shown in Figure 24 on page 72, and the colored illustrations on pages 74 and 75 (Palettes XV and XVI). Using tempera colors, prepare a series of medium tints (about halfway between purity and white), such as pink, peach, soft yellow, pale green, pale blue, lavender. Hold them as clean as possible and avoid grayness or blackness. Work out a simple pattern or sketch, with light gray or a soft tone for a background. In carrying out the design, let the original tints be confined to relatively small areas. For larger areas mix intermediate tones by adding neutral gray of lower value (this is important), or by combining opposites. Mixtures with gray are recommended as the simplest method.

When this drawing is completed and the entire area covered (no white should remain

PALETTE XV

exposed) airbrush a delicate coat of opaque pale gray (about value 6 or 7 on Figure 8) over everything until the drawing is somewhat grayish or misty to the eye. Now restore touches of the original clear tints—and they will be iridescent.

Another excellent method is to proceed as follows. Mix a series of clean tints, all of which correspond in value to steps 6 or 7 on Figure 8, page 24. Then mix a generous amount of medium gray (about value 5). Tone scales should now be formed by mixing this gray with the original tints. Each scale should have about three or four steps from clear tint to neutral gray.

Paint the general field of the design first, using the deeper and more neutral tones. Then scale the colors gradually into the clean tints which should be placed about as smaller touches, highlights or details. A general all-over gray cast will establish and fix the illumination quality. It will, by comparison, lend unusual glory and iridescence to the minor areas occupied by the clean tints. As with the lustrous effect, the illusion may not be wholly apparent until the entire surface of the drawing or design is covered. Once again pictorial art may profit—but what about non-objective art? Here where intrinsic qualities in color may be anything at all, the iridescent effect is rarely if ever seen.

The illustrations on pages 74 and 75 are somewhat complex. In the larger one, the over-all effect is grayish in tone, while the smaller one is in muted tones of beige. In each instance, however, it will be noted that the field is suppressed in tonal quality and that none of the colors is dark in value.

In the experiments described above, a middle gray field has been recommended and the iridescent touches blended into it. However, this middle gray field does not have to be neutral but could be a soft rose, green, blue, purple or anything else.

The iridescent effect is not a difficult one to achieve. Some patience may be necessary in the beginning, but once the principle "catches on," the artist should find delight in it.

It should be recognized that while color

Two effects of iridescence or mother of pearl. A generally grayish quality over the major area of the composition builds up a field in which light, clean tints take on an opalescent gleam. This effect is not due to the medium (printing ink) but to visual interpretation of what is seen.

PALETTE XVI

in itself is deeply appealing, the extra qualities involved in Perceptionism make possible even greater charm. A person may like pink or blue. Yet if he were shown pink or blue as lustrous, iridescent or luminous, he might be all the more pleased.

Many of my palettes and illustrations have been exhibited to artists and the public. Their human appeal is quite direct. Some artists, however, are likely to see "trickery" in them. This indictment, incidentally, was once laid at the door of the Impressionists, who were accused of doing flimsy things and of departing from the solidity and structure of the old masters.

Color must be a progressive art. Above all, because its beauty is so compelling to the emotions, it is hard to justify anything of a primitive attitude. A good part of modern art—particularly where it is abstract or non-objective—requires argument. I have noted, however, that where the color effect is original or dramatic, the forms are more readily accepted, even though they may be crude.

In other words, color holds a magic key to the sense of sight. As David Katz wrote, "Color, rather than shape, is more closely related to emotion." Why therefore shouldn't the artist seek new and unprecedented visions of it!

Experiments

Samples of iridescent materials should be collected and studied. These will provide a basis for the establishment of color effects. More or less subtle hues—purples, violets, yellow-greens, blue-greens—seem to be best associated with the phenomenon.

The artist may then perform the experiments described in this chapter. Simple designs, merely a few square inches in size, should be attempted first until the principle involved is fairly well understood. Once this is mastered, he should be able to add something of his own personality in composition or conception and really be proud of himself.

Figure 25. An impression of luminosity

18. The Luminous Effect

The illusion of luminosity in art is one of the highest expressions possible with color. Value its esthetic merits as you wish—but as an effect, striking to the eye and appealing to human emotions, it is rare among all color achievements. Accordingly, you will note that more space in this book is devoted to the luminous effect than to other color effects.

People instinctively respond to light and to luminous color. Some critics may argue that tricks in color technique are beside the point; art should not be a phenomenon. An attitude like this misses the point. Regardless of the intellectual bent of the artist, he can do with emotional support, and color—luminous color—is saturated with emotion.

There is no reason why a new school of Impressionism could not be built today. Through color the visual poverty of the art of this generation might grow more abundant, more robust, emotional and satisfying. Now it is lean and neurotic. Color could give it life again, fatten its tissues and redden its blood.

Glorious color effects do not have to be labored. They do not have to involve the intricacies of *chiaroscuro* or the self-torturing style of Seurat's pointillism. Such things as luminosity are, in reality, easy accomplishments. Art has missed them because it has not understood them. The principles are elemental. Why cannot these striking things be accepted by the artist and employed to new ends? Color by itself may be secondary. Yet an ambitious avatar of da Vinci or Cézanne ought to be able to create ageless beauty out of it by adding to it the force of his own individuality and imagination.

Luminosity is seen in sunlight on snow, in translucent objects, in water, sky, sunset, in certain flesh tones, in the luster of silk. These touches are commonplace in life. They are rare in art because the painter has seldom discovered ways of achieving them. These ways are now known.

Art dallies if it fails to make use of these new devices and to thrill the eye with luminous color experiences. The qualities men admire in the works of the Old Masters, the Impressionists, Whistler and Turner, are largely qualities of luminosity. Non-objective art, in particular, which does not have to imitate the natural, could accomplish wonders. Today, however, shapes and forms may be different, but who can say the same for color? If man is to devise that which has not been seen before in shape, he should attempt to show that which has not been seen before in color!

Pictures are seen in the interiors of homes and galleries. Normally lighted canvases seldom have an engaging color quality. But portray an uncommon luminosity, carry it into a room, where it may be seen as an impression of light that differs from the illumination of the room itself, and everyone will stand in awe. Plainly, one of the most fascinating sensations in art is to see in a painting a degree of illumination that is apparently brighter than that of the place in which it is exhibited. Another striking sensation is

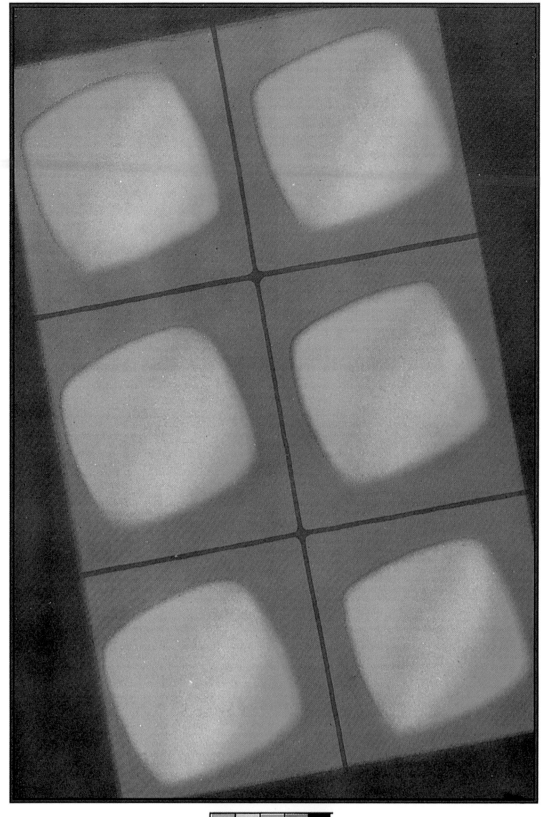

PALETTE XVII

to stand in normal light and view a canvas pervaded with a light that seems drenched with color.

The luminous quality of a hue can be accented in several ways. The simplest method is to surround it with dark values. Next is to surround it with its opposite. Both of these practices are traditional, but both fall short of real power.

Two contrasting values or two contrasting hues, side by side, may startle the eye. But both of the values or both of the hues may appear as though equally illuminated. White is not necessarily synonymous with much light, nor is black the direct descendent of darkness. As a matter of fact, white will look whitest in deep surroundings, and black will look blackest in bright surroundings. Luminosity follows more subtle laws than these.

Important to the simulation of luminosity and luster is the appreciation that purity contrast, not value or hue contrast, is what is needed.

Katz writes, "A color must be brighter than a white surface under the same conditions if it is to be characterized as luminous." This is the law. By "brighter" Katz refers mainly to illumination. As to luminous effects, remember that gray (chroma) contrasts rather than hue and value contrasts reveal the secret. Nor do the luminous tones have to be bright—they merely have to be purer than their surroundings. A dull glow of flame or light can be executed in soft tones altogether if the above principles are observed. Control of the field is all-important. The general illumination of the canvas should appear grayer than the luminous touches. An artist may paint in a straight-

Here is a convincing demonstration of the fact that visual appearances may be in the eye (and brain) and not necessarily in the object. In looking at these illustrations one is struck by a feeling of light rather than of printing ink. A new freedom for the artist lies in a study of human perception. Other illustrations of luminous effects are shown on pages 82, 83, 102, and 103.

forward fashion and with opaque materials. His edges (penumbrae) will be soft, rather than distinct planes. His contrasts will be gained by blending neutrality into purity. His canvases will glow!

Luster, iridescence and luminosity are quite similar as visual phenomena. The scientist, in fact, has found that on the outer boundaries of the retina of the eye the three may be readily confused. Luminosity, of course, may reach high degrees of intensity in various light sources. As a principle of Perceptionism to be applied in the art of color, it offers one of the most fascinating of all expressions.

It should be recognized that luminosity in human experience is not necessarily related to the volume of light that reaches the eye. In dim surroundings a mere candle flame will appear luminous. Yet out in the open on a sunny day, even a sheet of white paper will not appear luminous, even though it may actually have the brightness of a thousand candles. Everything depends on what is seen in the general field of view. What is seen in the general field will inform the eye as to the nature of the colors before it.

In the history of painting, luminosity has often been attempted through physical devices. Layers of transparent color have been washed over gold leaf. Gems and semiprecious stones have been introduced. The beauty of luminosity, however, may be easily and effectively achieved without depending on material qualities in the pigments used. Through a carefully established arrangement of color tones and values, the eye may be convincingly led to believe that light is being emitted from the surface of a draw-ing. The illusion is always compelling and intriguing and is one of the most remarkable of all accomplishments in the art of color.

For a paint or dye to appear luminous, the following conditions must exist in a drawing or design:
— The area to be made luminous must be relatively small in size.
— It must be purer in chroma than its surroundings.
— It must be higher in value than its surroundings.
— Its hue quality (red, yellow, blue, etc.) must seem to pervade all other colors in the composition, just as though such a light were shining upon the entire drawing.
— Deep values must be avoided. When light shines into the eye, it tends to blur vision and make all adjacent objects appear soft and filmy. Black, for example, will lose its harshness and appear deep gray and atmospheric.

Refer to Figure 25 on page 76 for a simple illustration of luminosity in black and white. Note that the contrast between the luminous area and its background is moderate rather than extreme.

Now refer to the illustrations on pages 78 and 79, based on Palette XVII, one of the most successful I have done. Only five colors were used in the execution—a bright pinkish red, a bright blue, a pale intermediate neutral tint, and a medium and deep blue on the grayish side (for the background). There is a cross-play of red and blue light, very convincing of the illusion that one sees illumination and not mere paint or printing ink.

These studies were made as follows: First the areas of luminous red and luminous blue were laid down in intense or highly chromatic pigments. Lights, of course, are additive, and this is one significant key. The intermediate neutral tint, blending between the red and blue, was made by adding touches of red and blue to a considerable amount of white. (If the red and the blue were allowed to overlap or shade into each other, the result would be dark and subtractive, not additive, and the effect would collapse.) The medium and deep grayish blues of the background were then sprayed with an airbrush. Once a palette like this is accurately fixed, creative art of any sort may be quickly accomplished.

The illustrations on pages 78 and 79, therefore, meet the following requirements:
— The luminous red and blue areas are relatively small in size.
— They are pure in chroma and fairly high in value.
— The intermediate, blending tint, is pale to respect additive mixture.
— The grayish blues in the background provide a slightly neutral field of contrast.
— The transitions are subtle, like light itself, and help to heighten the illusion.
— All in all, this is not a mere red and blue color *scheme*, but a luminous red and luminous blue color *effect*.

In the illustrations on pages 82 and 83, based on Palette XVIII, an attempt has been made to introduce the light source itself into the canvases, and to have a weird yellowish green light pervade the compositions. Note the lack of value contrasts. If the light source itself were truly brilliant, it would naturally affect everything else, and dark colors would be softened by luminous haze.

Now refer to the three illustrations on pages 102 and 103 (Palettes XXV, XXVI, and XXVII). Two were done in only two colors. The third introduces a few touches of luminous blue, resembling stars, although the figure and ground are essentially comprised of a pair of colors.

These illustrations have been reduced to essentials, and yet they shine like light itself. How were they done? In each instance, the dominant illumination on the figure was established as the light source. The effect of this light source was then studied in its action on other colors. (I actually threw colored light on a color circle of pure hues.) I then matched the result of colored light on pigment, and after a series of trials and errors, found the complements which best created the effects I wanted—which are illustrated. This took time, of course. But once I knew how to achieve the effects, the drawings themselves were executed (by other artists) in no time at all.

It may be observed that in perception there is a difference between an area or object that gets its color from the outside and one that is self-luminous or luminous from within. The former color effect is recognized for its influence over the objects or areas it illuminates (see Chapter 19). The latter has the appearance of light itself. Hold a piece of thin white paper in your hand. With your back to the window and with the light falling over your shoulder, the paper is *illuminated*. When you face the window, hold the paper and let the light shine through it, the paper seems to be *luminous*. The amount of

PALETTE XVIII

light energy is not a significant factor here, for sunlight itself may not make things luminous, whereas the feeble light of a candle may well do so. It's all a matter of perception.

Luminosity in the psychological sense appears to come from within an object. And light, to appear as such, must be filmy. Texture also enters the picture, for while *surface* colors usually contain texture, light itself is free of it.

In working with paints and pigments, therefore, some ingenuity must be shown. Paints are inclined to be textured, to show a grayish or blackish quality. They persist in reflecting light in the manner of surface colors. It is their nature to be opaque rather than luminous. Also, the technique of the artist may show brushmarks and imperfections. The background or canvas may show

through as microstructure—all to defeat the quality of light. Light has no bulk. It is filmy and transparent and never part of a surface. The surface it shines upon or through has structure; light never does. How, then, to give luminosity to pigments?

The illustrations on pages 78, 79, 82, 83, 102 and 103 capitalize on this phenomena of perception. The light sources—coming from inside or outside the drawings—cast their influence on the entire compositions. In most cases the luminous colors are flat, without texture and have the characteristics of light. They also constitute the lightest and purest areas—effectively set off against slightly deeper and more modified tones. Add all this together, and the eye is forced to see what the artist intended.

The luminous palettes included in this book may be simple enough as finally

An effect of luminosity, with the light source shining from within the composition itself. Note that the palette consists of only four colors. There is a minimum of contrast in value as well as hue. For in perception, if light strikes the retina, it has a hazing and spreading action — well caught in these illustrations, one abstract and one realistic. Other illustrations of luminous effects appear on pages 78, 79, 102, and 103.

chosen, but a great amount of study and observation have gone into their original development. Surely this impresses the point that nothing has to be labored except the mind. That is, while the writer may have worked hard at his concepts of luminosity, once he had them apprehended—and his palettes established—the finished art work was done quickly, and directly, with minimum effort.

Luminous effects may be designed to simulate such things as sunsets, lighted candles, patches of sunlight and dozens of other natural phenomena. To my way of thinking, they could break non-objective art wide open and complement new design conceptions with new color sensations. It is always important, of course, to hold the luminous touches slightly lighter in value and purer in chroma than their surroundings—

and to indicate that the glow of the luminous area shines on all other areas.

Experiments

Perform the experiment described in this chapter. Remember that wherever light is found to shine it tends to be filmy in quality and to have soft, fuzzy edges and halations. This technique itself will aid the illusion of luminosity.

The best mediums to employ are tempera colors, pastel crayons or oil paints. (With transparent water colors on white paper, the effect is almost impossible to achieve.) Also, the luminous quality may not be apparent to the eye until the entire area of the drawing is covered. Thus the artist cannot judge results until his effort is completed.

19. Chromatic Light

Much has been said about the peculiarities of illumination, the fact that it seems to be an experience aside from the things in the world itself. The eye senses chromatic light of its own accord, and it also establishes the quality of this light by judgment of the surfaces that are colored and distorted. Few people even casually notice modifications in the tint of daylight which may vary throughout the day from white to pale yellow and rich orange. Nor do daylight and incandescent light seem to hold much difference. When the coloration is stronger, then the result is naturally more arresting.

As to art expression, if a composition in natural colors were to be viewed under colored light, the eye and the brain would catch on as to what was taking place. However, if the painting appeared to be flooded with colored light, although it was viewed under normal illumination, the reaction would be quite surprising. The mellow beauty of many old paintings is due to this phenomenon. It has often been caught in representational art, but has been largely missed in non-objective art.

Illumination effects are always dramatic and appealing, and methods for their accomplishment will be described here.

In the phenomenon of color-constancy the human eye is able to maintain a fairly normal perception of colors under widely different illumination intensities. This fact also holds true of chromatic light. When a room is flooded with colored light—red, yellow, green, etc.—white surfaces will still persist in looking white, even though certain obvious distortions will be apparent. Once again, color as sensation and color as physical energy stand apart. A white surface showered with chromatic light is, technically speaking, no longer white. When the eye sees it as such, the mystery lies not in physics but in the curious psychological makeup of human vision and perception.

When the influence of colored light upon colored surfaces is studied, one learns that such "mixtures" do not always correspond to the mixtures of pigments. In light, a warm red and a turquoise blue are complementary and when mixed together will form white light. Green and magenta are likewise complementary in lights, as are yellow and blue-violet. (See page 18.) Yellow light, therefore, will neutralize a color such as ultramarine, whereas a similar mixture of paints would form a dull green.

Chapter 13 on dominant harmonies has mentioned the beauty of color schemes in which one particular hue is made to predominate. The technique studied, however, was one involving pigments rather than lights. It by no means reaches the perfection to be described in this chapter.

Study the palettes and illustrations on pages 62 and 63, 66 and 67. These show examples of the principle of chromatic light carried out in terms of red, yellow, green and blue. Note how all tones contribute to the general effect. The studies were actually worked out by analyzing the influence of colored light on other hues. They were *not*

PALETTE XIX

done merely by adding a proportion of red, yellow, green or blue to the other pigments.

Here are a few preliminary points to consider. Thinking in terms of an over-all field, if chromatic light affects surface colors (paints) in certain unusual ways, what will happen if these modifications are duplicated with pigments and carried out on a drawing or design? Using pigments matched to resemble the effect of colored light on colored surfaces, can they be made to create an illusion of colored light?

The answer is definitely yes, as the illustrations confirm. Drawings executed in ordinary art mediums such as tempera colors, water colors, oil paints, pastel crayons, etc., may be made to create a perfect illusion of chromatic light and to convince the eye that the effect is one that owes its striking appearance to tinted light. Again it is possible to have the expression transcend the materials—always an eminent achievement.

To experiment with the effect of chro-

matic light, the following procedure may be observed. Prepare a simple color chart (on black board) consisting of samples of any miscellaneous collection of hues—red, yellow, green, blue, purple, white, gray and black. It is best to have these base hues slightly tinted with a small touch of white.

Refer to Figure 26. Set the chart (*a*) upright on a table so that it may be swung on its vertical axis. In front of this chart place a sheet of colored cellophane (*b*) or colored glass. Having a drawing or sketch in mind, proceed to match the colors *on the chart* as they appear to the eye *through the cellophane*. Such matching should be done at point *c* on Figure 26. (Matching will be easier if a small black card with a hole in it is used to isolate the color being studied on the chart.) Normal light, preferably from a window, should shine uniformly from the left.

With a piece of yellow cellophane for a screen at *b*, for example, mix a pure yellow pigment, hold it in a straight line at point *c* and swing the chart (a) *until the white square on the chart matches the sample of yellow paint.* This will be done by comparing the yellow sample against the *white square* seen through the cellophane.

Now proceed to match other colors on the chart, holding them at the angle determined as above. What influence does the yel-

Two examples of chromatic light which use the same palette of nine colors. The over-all atmospheric quality has been arbitrarily fixed in the yellow-green region of the spectrum. (It could be any other hue.) Human perception, once understood, may be controlled at will by the artist. Other illustrations of chromatic light effects appear on page 62, 63, 66, and 67.

low cellophane screen have on red, green, blue, purple, etc.? All matching should be as accurate as possible. Do not attempt to match what you *think* you see; the phenomenon of color-constancy may confuse you.

With a palette so formed, use it to compose a simple abstract or pictorial design. As you progress, the incomplete results may appear rather queer and ungainly. Blue on the color chart, matched through the yellow cellophane, may turn out to be a muddy shade of olive. Red may turn decidedly orange. Violet and lavender may be a nondescript gray. Until the entire area of the drawing is covered, the experiment may appear anything but successful.

However, a very unusual demonstration with color harmony will be achieved. Try similar experiments with other colors such as red, blue, green. Some of the colors on the chart (*a*) may go darker than your paints, but go after them as best you can. For real emphasis and unquestioned effect, avoid very pale tints for the color screen (b); they may be too subtle.

Now study the illustrations on pages 86 and 87, both of which were painted from Palette XIX, one non-objective, one realistic. Each painting was done with nine colors which were, of course, intermixed. The prevailing illumination is an eerie yellow-green. There is considerable invention and imagination in these two exhibits. With color under perfect control the luminous result would do credit to a great artist. The over-all effect (*in color*) is highly original, luminous and has great emotional impact.

Striking color effects are more dependent on mastery over illumination than on adept-ness in the arrangement and harmony of colors themselves. In view of what has been said in the last four chapters, it seems quite academic to talk about colors as things in themselves or to discuss their arrangements as things apart from sensation.

The Renaissance mastered the *chiaroscuro* style and gave beauty and texture to form in two dimensions. Artists such as Velasquez and Rembrandt did marvels with light and shade and had a knowledge of color-constancy through sheer genius.

Perhaps the greatest of all painters of luminosity was Georges de La Tour whose genius is being recognized today. He put light sources within his canvases and achieved uncanny effects.

Claude Lorrain and Watteau, among others, brought out the qualities of color divisionalism. Delacroix and Turner were fascinated by natural phenomena, atmospheric effects, complementary colored shadows. Whistler achieved luminous touches through the subtle contrast of grays.

Monet, Seurat and the school of Impressionism sought to paint light itself. Cézanne fought for a return to solidity in art. Van Gogh successfully gained illusions of chromatic light.

Today art has changed. One notable shift has been from naturalistic effects to non-objective. Obviously, any artist who deals with landscapes and figures must adhere more or less to natural phenomena—and these are limited.

Yet in the realm of perception, man may create phenomena of his own. Nature does not exhibit many of the effects illustrated in this book. Sunlight or sunset does not shower

the world in yellowish green, turquoise blue or other odd hues. However, chromatic light, chromatic mist, in non-objective art, may take any direction the artist wishes. He can devise and establish beauty which does not exist in nature at all!

If I may make my point clear, the art of the past has mostly vied with nature. Today it may transcend nature by working with human perception directly and thus be as individual and original as man is able to imagine. Certainly modern art *forms* have departed from reality or likeness to familiar things. Yet the colors are the same. Why shouldn't the new concepts of shape and form be complemented by new concepts of color? I am convinced there is a whole new world to conquer.

Experiments

Carry out the experiments described in this chapter. It is best to avoid very deep and rich hues for the transparent sheets; they may be too difficult to match. Extremely pale transparent sheets should also be avoided, for they may fail to give enough emphasis to the chromatic illumination effect. Ordinary colored cellophane purchased in stationery stores is satisfactory.

The principle involved here is not a simple one. However, it is well worth the effort. Once the artist comprehends the influence of colored lights on colored surfaces, the more or less mechanical method of matching, described in this chapter, may be abandoned.

Figure 26. Arrangement for the study of chromatic light and chromatic mist.

PALETTE XX

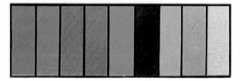

20. Chromatic Mist

The effect of chromatic mist closely resembles that of chromatic light and affords another demonstration of Perceptionism. The chief difference, however, is that softer and more refined harmonies are possible. Also, the appearance of the finished drawing or design suggests a feeling of atmosphere or space.

In nature, fog and mist will pull all distant colors into concordant relationship. Yet these atmospheric effects are largely grayish in quality—or delicately bluish or delicately purplish. Assume now that nature suddenly drenched the fog with dyes in red, green, blue, orange, yellow! Surely a new world of color experience would be unfolded.

The glories of chromatic mist may be easily studied. Using the arrangement of materials and charts illustrated in Figure 26 on

page 89, transparent sheets of colored cellophane (at point *b*) are replaced by a clear glass tank measuring approximately 5 or 6 inches square and about 2 inches between its faces. (A glass tank of this type, optically polished, is commonly used as a heat filter in projection equipment and may be purchased from such a supplier.)

This tank is filled with clear water. A touch of dye or colored ink is added in any desired hue. A tint rather than a pure color should be so mixed. Looking through the tank the effect will correspond with that seen through cellophane. However, if a drop or two of milk (or milk of magnesia) is added, the mixture will immediately cloud up, and a chromatic mist will be formed. The procedure now is to match the colors on the chart by looking through the tank—as described in the last chapter. Such matching, of course, will take place at point *a* in Figure 26.

In matching pigments through clear colored cellophane a number of phenomena have perhaps been noted. Hues on the chart which are complementary to the colored

Examples of chromatic mist accented by a few touches of iridescence. While such atmospheric effects are quite limited in nature, the artist may, through an understanding of human perception, create them at will. The eye may be led to see intriguing effects which it may fully appreciate, and yet the experience of them may be wholly new.

cellophane may turn unusually deep and may defy accurate matching. Likewise, colors similar or analogous to the colored cellophane may have extremely rich chroma.

Fewer of these difficulties will be encountered in the study of chromatic mist. However, the water solution in the tank should not be made too intense in hue nor too cloudy from adding too much milk. All colors seen on the chart will assume a soft and delicate quality that may be easily duplicated with paints (tempera or oil). Light values may deepen a trifle. Deep values such as black, maroon, brown, will grow paler and will lack their original heaviness and harshness.

As in all experiments involving a specially controlled field, the hoped-for effect may not be apparent until every square inch of the drawing or design is covered. Then the result, if carefully executed, will have a unique charm and should immediately suggest a wealth of creative possibilities in pictorial art or non-objective design.

Examples of the effect of chromatic mist will be found on pages 90 and 91, Palette XX. The composition suggests an underwater scene predominantly bluish-green. Space and distance seem well implied. Note that a few incidental touches of lustrous tints have been introduced. These owe their brightness and sheen both to direct hue complementation and to the grayish contrast provided by the blue-green ground which is relatively weak in chroma.

In the tradition of painting, chromatic mist effects were related to what was called aerial perspectives. Some of the Old Masters used different palettes on foreground, middle ground and distance. Being realists, however, they did not conceive of such perspective in terms of unusual colors. It remains for modern artists to do this.

As far as color is concerned, all of beauty is by no means in nature. Wonderful though she is, she has missed a lot of effects which man, in his ingenuity, may now attain. Modern science, with its enlightened knowledge of perception, has much to teach the artist—and the phenomena of chromatic light and mist are literally shining examples. Appreciate how perception operates, how man sees the way he does, and the findings of the psychologist may be turned to remarkable ends.

Because of the predominantly grayish effect achieved in the principle of chromatic mist, a further expression of luminosity may readily be added—to heighten the illusion of light shining from within the drawing. Refer to Figure 27 in black and white (and to the next chapter). If certain small areas are made the lightest and the purest touches in the field, they will appear as colored lights or stars which have a beauty that may seem quite apart from paint itself.

In carrying out the principle suggested in Figure 27, color complementation may be introduced. For example, the major areas of the design may be based on a study of surface colors under a delicate purple or lavender mist. (See page 106.) Small, luminous touches may then be added in other colors such as pink, yellow, green. If they appear too sharp, they may be shaded off with halos by mixing a small touch of lavender with them for intermediate gradations into the background.

Simple experiments should be performed in accordance with the discussion of this chapter. Care should be taken to avoid too much color intensity or opacity in the tank mixture. It is best for the artist to try his skill at various simple effects until he has a fair comprehension of chromatic mist.

With the principle well understood, the use of the tank and chart will no longer be necessary. The harmonies discussed in this chapter have good application to pictorial art and landscape painting, illustrations, etc. However, in non-objective art, where natural appearances are not required, completely different and "out-of-this-world" color effects may be created.

Figure 27. An impression of luminosity in mist.

PALETTE XXI

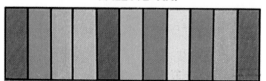

21. Luminosity in Mist

As far as my research has gone, the most advanced—and perhaps complex—color effects I have been able to achieve are reproduced on pages 94 and 95, 106 and 107 (Palettes XXI, XXII, XXVIII and XXIX). Here I have combined the principles of luminosity with colored mist, attempting to put together two unusual phenomena in one over-all scheme.

It would be difficult to create luminous effects to accompany effects of colored light (without mist) for the simple reason that in such compositions it is necessary for the artist to mix hues of strong chroma. He therefore would not have the softer gray contrast he needed.

Consider blue as an example. If transparent blue were used for the screen (*b* in Figure 26), such colors as red, yellow, green on my basic color chart (*a* in Figure 26) would turn out to be extremely rich and probably stronger than any paints that could be mixed. And if the whole canvas was so covered with rich hues, the artist could not build up luminous touches to exceed them in chroma. Thus he could not take advantage of the curiosities of human perception.

However, with chromatic mist this difficulty is not faced. Misty effects owe their existence to a quality of grayness and to pale and middle values. Their essential "softness" offers a wonderful opportunity to establish an atmospheric field and then "punch" in truly luminous areas.

Study pages 94 and 95, 106 and 107 which show mist effects in blue, pink, lavender and chartreuse. Understand that it is wholly possible to carry out any of the principles of this book in virtually any color scheme. Once the artist knows what he is about, once he grasps the strategy of achieving luster, iridescence, chromatic light, chromatic mist, etc., he may work in any region of the spectrum he desires. If he does representational art he may pay tribute to nature, but if he is an abstractionist he may go as far as his imagination leads him.

Let me explain how luminosity in mist is

Two effects of luminosity in mist. Where successfully achieved, the eye is less conscious of a scheme involving differently hued areas (or paints) but of an interplay of colored light. Perception is inspired to take part in the result and to see far more than is actually on the drawing. Other examples are shown on pages 106 and 107.

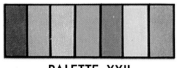

PALETTE XXII

accomplished, using the blue scheme on page 94 (Palette XXI) as an example.

Observe at once that you see shining lights in color—and yet the whole canvas is fairly light in value. I have not used dark contrast; even the deepest tones in the composition are far from black. The background field was simply done. I set up a misty blue tank and matched white, gray and black. These three tones (under the influence of blue mist) were then mixed together freely and used for the non-objective forms which occupy the largest area and set the key for the canvas.

A purple, a warm red, a yellow and a green were then arbitrarily picked out and made as pure as possible in medium tints. These were made the luminous sources. They were the purest hues in sight and were also just a trifle lighter than the over-all tone of the background.

Now, and of real importance, the effect of blue light was studied as it changed the color of the purple, red, yellow and green tints. The tank in Figure 26 (b) was used for this purpose. Four paints, showing this influence of blue mist, were then applied to the abstract forms. Transitions were now made between the pure pastels and their counterparts muted by the blue illumination. A bit of contrast was added with dark blue, and (presto!) the lights went on.

To an artist who might say that this is trickery, I would put up a vigorous defense. From experience I doubt if even a skilled artist could take a look at these illustrations and then, on his own, do as well. If he worked with a crude palette squeezed from tubes, his paints might well hold to the ap-

pearance of paints and not grow luminous. The effect on page 94, as a case in point, conceivably could have turned out to be a blue color *scheme* to which bits of purple, red, yellow and green had been added. But it is not a color scheme at all but a dramatic color *effect*. The eye is greeted with a refreshing experience, and the artist has made pigments do obediently what he commands.

Figure 27 (page 93), using black and white, shows an example of luminosity in mist. Also refer to Figure 28 on page 97 and the following facts: In the real world, light sources visible to the eye may be brilliant. Here brightness, in relation to the surrounding area, may have a high ratio. However, on a canvas (or in a photograph) brightness ratios rarely exceed 17 or 18 to 1, assuming that a white paint will reflect about 85 per cent of light and black paint 5 per cent. Yet the headlights of an automobile, shining in total darkness, may exceed the darkness of night by a ratio of several hundred to one.

Yet from the viewpoint of *perception*, this physical fact does not seem to apply. Light striking the eye tends to create haze and blur which "fogs" the field of view and appears to reduce contrast. Black surfaces, where luminosity exists, are no longer black but a filmy gray.

In Figure 28, the lamp post on the left, in black and white, appears less luminous than the one on the right, yet the contrast is as great as printing inks can achieve. In the lamp post on the right, however, although the contrast is substantially reduced, and close values of gray are employed, the effect is more luminous. Here illusion is created, not in terms of what may happen in nature,

but in terms of the way perception interprets luminosity. Thanks to the psychologist one may comprehend the principles involved. The artist does not have to resort to physical devices but may *imply* luminosity by reproducing the way that it appears to the human eye.

The Impressionists sought to paint light, and so have I. Although the two courses have been different, thanks to the cumulative labors of the scientist in the field of human perception, a whole new world of expression has been discovered for those who wish to explore it. But they will have to learn something. Fortunately, this something concerns themselves and their own consciousness. Unlike formal color training, which is cold and impersonal, training in Perceptionism becomes very personal. It is a joy to study because it deals with human reactions.

Experiments

The color scheme described in this chapter may be worked out by the artist using tempera or oils. If this is difficult, he may note the Munsell notations at the end of the book for the precise colors that have been used in the preparation of the illustrations. He should also study phenomena in nature, sunsets, fog, lighted cities in drizzly weather. If he has good powers of observation —and knows about his perception—he should gain real competence in creating effects of luminosity in mist.

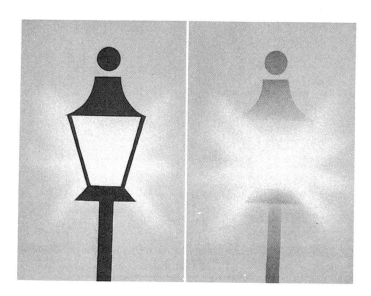

Figure 28. A luminous source tends to destroy contrast.

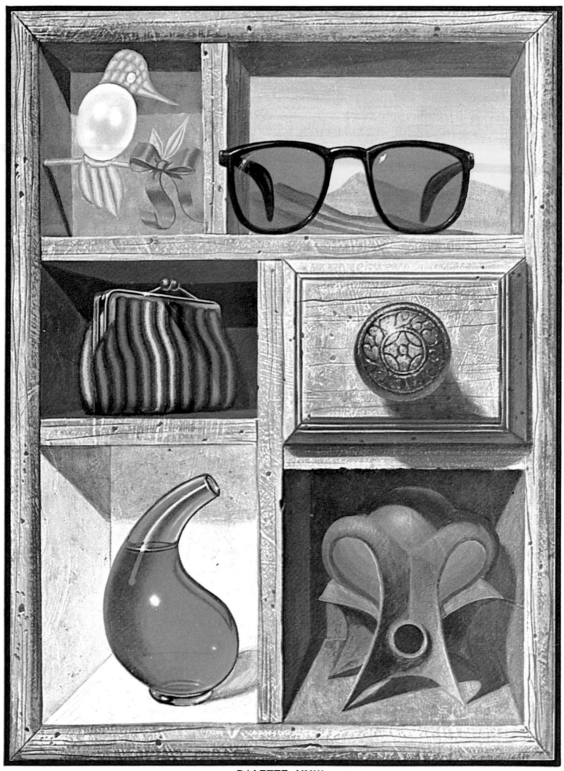

PALETTE XXIII

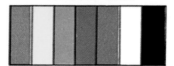

22. Transparency, Texture, Solidity

Although texture offers many possibilities for added beauty in the development of color schemes and color effects, it is frequently disregarded. The artist or designer often forgets that color expression may capitalize on other qualities than hue, and that texture is one such important quality. Filmy colors will differ in artistic feeling from more structural surface colors—even though they may match in hue.

The artist who appreciates the role of Perceptionism knows that texture offers added dimension to his effects. Assuming that the average person likes red, surely this favorite will arouse subtly different emotional responses if seen not merely as paint but as a luminous red, a lustrous or iridescent red, a filmy or transparent red. An artist may tend to think of color as a thing by itself and to neglect the extra beauty which a feeling for texture may impart.

Refer to Figure 29 which shows an effect of transparency in black and white. Here once again the composition is one of grays— but the *effect* is far more than this alone. One sees a transparent film or membrane laid over a conventional background. The eye (and the brain) participates in the result, and an unusual visual experience is gained.

Now refer to Palette XXIV on page 99 which shows transparency in full color. Here pieces of colored cellophane or glass seem to have been applied over a beige ground and made to overlap each other. How was this illusion achieved?

To begin with, if actual pieces of colored cellophane were pasted over a drawing, the eye would promptly discover the trick and discount it accordingly. Nor could the effect of transparency be achieved with an air brush—for the simple reason that pigments

Illustrations show modes of appearance of color and an effect of transparency. To color as a thing in itself may be added these extra qualities of texture — many of which may be effectively simulated through an understanding of human perception. It is within the artist's power to imply virtually anything.

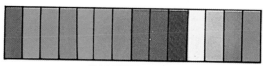

PALETTE XXIV

do not mix in the same manner as lights. This was discussed in the first section of this book.

Palette XXIV was worked out as described in the chapter on Chromatic Light. The color scheme for the beige ground was established first. Then samples of these colors were pasted on a chart and their appearance matched through colored cellophane. Each of the colored transparencies was thus given its own palette. The design was then put together as you see it.

Thus to such effects as luster, iridescence, luminosity, chromatic light and chromatic mist, add the further dimension of transparency.

Still other unusual appearances and textures for color are to be seen on page 98 (Palette XXIII). Through a careful application of principles already described, the eye sees luminosity, volume color (three-dimensional), transparency, luster, iridescence, a metallic form and various surface textures. The composition, though realistic in treatment, is also surrealistic and imaginative.

Naturalistic painting has tried to achieve the qualities which are seen in life. However, non-objective art is a field where these qualities could be exploited in unusual ways to complement unusual forms. Areas of color, instead of appearing as mere flat impressions of pigment, could resemble other textures altogether and thus offer new visual enjoyment. In brief, the most conventional of color *schemes* may be turned readily to intriguing color *effects* if resourcefulness and skill are shown.

The seven colors shown with Palette

XXIII were used for the composition in general—a series of "dusty" hues which provide an excellent field for the accents placed upon them. The colors for the touches of luminosity, luster, iridescence, and the like, were then derived from principles set forth in other chapters of this book. Thus, in this illustration the artist has begun to coordinate various effects and to combine several principles into one.

Let me emphasize that this is essentially a "study book" which in fairly orderly fashion describes and illustrates a number of visual phenomena. Each chapter may be complete in itself, but by no means is meant to be restrictive. That is, once the artist has grasped the separate points and principles I have tried to make clear, he may then consider himself free to mix them together or otherwise improve upon them and create advanced art forms on his own. I wish him good fortune.

In a broad sense, color textures divide themselves into two main classifications— solidity, or lack of solidity (filminess). This difference also involves matters of space relationships, perspective, dimension.

Modern schools of art have emphasized three-dimensional qualities in painting. Cézanne was fascinated by the idea and sought to develop it through various devices. Some purists, however, have decried attempts to create three-dimensional effects on two-dimensional surfaces. They argue that such attempts are presumptuous, artificial and even dishonest. If an artist works on a flat plane, why should his art strive to "lie" about this fact?

The purist may be right, but I will not

dispute with him. If perception can see relief on a flat surface, at least this has its measure of fascination—polemics to the contrary. In any event, I am not concerned with the philosophy of art, but simply with the magic of human vision.

What principles may be used to force one element in a drawing or design to stand apart from its surroundings? What will best effect the illusion of three dimensions?

Solidity and form may be dramatized as follows:

1. By contrasting lightness against darkness (but not against blackness).

2. By contrasting pure color (or black and white) against grayed color.

3. By contrasting warm color against cool color.

4. By contrasting detail, texture and microstructure against plainness or filminess.

5. By introducing perspective to distinguish near from far distances.

6. By implying a continuation of background design elements running behind foreground feature elements.

7. By showing highlights and cast shadows.

8. By using recognizable objects which, because of relative size, will give mental clues to their near or far positions.

The illustration on page 110 puts a number of these principles to work. To the artist who wishes to undertake a complex but intriguing challenge, let him try his own hand at the problem. If the endeavor is only partly successful, let him realize that he is experimenting on lofty ground. He will be concerning himself with expressions and ef-

Figure 29. An effect of transparency.

PALETTE XXV

 PALETTE XXVI

fects which have engaged the best of genius in the history of art. (Also see Chapter 24.)

Finally, in the matter of form, the fact should be recognized that the eye will more sharply focus on a warm color than it will a cool one. This is due to the makeup of vision itself and accounts for the general blurring of blue, violet and purple when seen at a distance. In an abstract sense, therefore, red, orange and yellow are best associated with angular and sharp forms; blue, violet and purple with softer forms.

Experiments

At least one experiment should be performed to achieve the effect of transparency. The principle involved is to color a drawing or design and make it appear as if seen through a transparent colored film. It is best to have the background colors grayish in tone so that full brilliance for the colored transparency may be easily achieved.

As far as this chapter is concerned, however, major study should be given to the problem of solidity and three-dimensionalism. Although this form of expression is sure to be complicated, it should prove stimulating to the imagination and inspire real ingenuity on the part of the artist. Pictorial or abstract compositions may be worked out.

In these examples of luminous effects, note that the eye translates printing inks into light. A person does not see colored flesh, but normal flesh pervaded by tinted light. There is a difference. Here the artist, by understanding perception, gets the viewer to take part in the result. Other illustrations of luminous effects are shown on pages 78, 79, 82, and 83.

PALETTE XXVII

23. Highlights and Shadows

Modern scientific investigation in the field of vision has revealed many important facts and observations. Appearances of color are often highly psychological and owe their impression to happenings that take place in the human brain.

The uses of color in pictorial art involve many problems which can be solved more satisfactorily once the artist has a fair understanding of their nature. In truth, a close familiarity with color phenomena will not only prove enlightening, but will enable him to go at his tasks more directly and to be shrewd and discerning in all he attempts. He may frequently forego the hard road of trial-and-error entirely—and derive real profit from the knowledge he has gained in advance.

Light and shade usually have little part in non-objective art, for they tend to imply realism. Most abstract painters deal with colors as distinct parts or units in various shapes or patterns, which are not representational but free forms. But in pictorial art, light and shade are inseparable from illumination, form, structure. They exist in relationship with other colors and not distinctly by themselves. A highlight, isolated from the object it molds, may be merely a pure or light color—and a shadow isolated may be merely a shade.

One of the common difficulties of the painter is to master the intricacies of highlight and shadow. It is helpful to know that, to the eye, highlights appear opaque and shadows appear transparent. While the high-light may seem to cover an object, like a bright spot of paint, the shadow melts into it and becomes a part of it. That is, shadows on flesh will still resemble flesh. They will not appear grayish or muddy—a result that often plagues the young painter. Similarly, the shadow on an orange vase will still look orange and not brown.

Such qualities must be preserved in representational art. Shadowed colors must maintain a normal appearance and not look strange and foreign to the object which they are supposed to model.

What makes a shadow appear soft and transparent rather than thick and opaque? One authority on vision has stated, "The importance of a shadow is its edge." Refer to Figure 30. If an object is made to cast a shadow on a white surface, the shadowed area will still appear white. Yet if a black line is drawn around the edge, the shadowed area may now appear definitely gray and not white.

Delicate transition is therefore often vital in the simulation of shadows. Again, as the light on an object swings into shadow, two happenings take place. First, the hue of the shadow also shifts to the next adjacent color on the lower side of the color circle. Thus the shadow of a warm yellow is a soft orange. The shadow of a cold yellow is a soft green or olive; the shadow of red, purplish; the shadow of green, bluish; the shadow of blue, violet. Second, the chroma of the shadowed color weakens, turning grayish or blackish. From full light to shadow, there-

fore, any given color shades toward its adjacent of lower value and toward grayness or blackness at the same time.

If these points are remembered, the realistic formation of shadows will not be difficult. Also, any medium may be used, opaque or transparent, with equal effectiveness. It is merely the *appearance* of the shadow which must be transparent, not its actual execution. And the edge should by all means be soft.

Highlights are of two types—specular reflections and true highlights. Specular reflections are mirrored images and may bear no relation to the color of the object itself. For example, the blue light of the sky, shining through a window may be mirrored quite exactly on the curved form of a shiny black vase, or one of red or any other color. True highlights, however, are seen as intense and highly chromatic exaggerations of the body color itself. And they generally swing in hue toward the next higher adjacent. Highlights on red have an orange glint; highlights on blue are slightly greenish. They have the aspect of luster or luminosity, being more or less brighter than normal.

Colored objects, from highlight to shadow,

form uniform chroma scales which have been previously described, except that the body color will swing in hue toward a deeper adjacent as its shadow grows darker, and toward its higher adjacent in highlight. One important point should be recognized. The highlight of a pure color is never a tint! To use pink for the highlight of a red vase is to violate fact and create an ungainly effect. A true highlight (not a specular reflection) represents a still purer expression of the body color itself.

Many great painters have dramatized highlights by painting all other areas on their canvas in suppressed tones. By thus taking advantage of the Law of Field Size or Proportion, they have been able to achieve striking results. Rembrandt followed this principle in giving luminosity to his flesh tones. A generally deep and subdued field endowed his canvases with the feeling of slightly dim light. This in turn gave the eye a comparison and enabled it to see, in the flesh tones, a quality of brightness that apparently was over and above that of the pigments themselves. The illusion was not a mechanical one, but was based on the Law

Figure 30. Shadows require a soft edge, otherwise they may appear like an opaque color.

PALETTE XXVIII

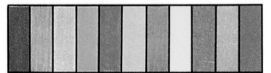

of Field Size or Proportion; the major areas of the canvas were painted in suppressed tones, thus heightening the illusion of luminosity in the featured flesh tones.

Because highlights are opaque in appearance, they are relatively simple to achieve. Shadows, however, are far more complex. Nothing else in artistic expression or technique is so difficult to portray as a good shadow, one that looks like a shadow, not a mere shaded color or a thick substance. A shadow should give the impression that it is transparent, that the surface or object it covers is normal.

Bühler has elaborated Leonardo da Vinci's descriptions of shadows. They are: conjoined shadows, air shadows and cast shadows. Each has a different appearance and should be appreciated in its uniqueness. Study the black and white sketches in Figure 31.

The shadow on an opaque object—a vase, still-life, or figure—melts into it and seems to become a genuine part of it. Conjoined shadows are what give plastic character to the world. They cling so closely that they become part of the genuine color of the object. A conjoined shadow must belong to something. It should not appear foreign. Modelling a face, for example, it must reveal flesh tones within its depths and not resemble bits of toned paper pasted on top. (See A in Figure 31.)

A shadow cutting through space causes the space to appear dark. It seems to be capable of filling space, while the areas around it may appear distinctly brighter. Such effects may and should be carried out by the painter. If a shadow is thrown *in front* of an object, the appearance of the air shadow may be achieved by painting the object in slightly darker light. (See B in Figure 31.) Just as an artist will throw rays of light across a canvas in mechanically straight shafts to indicate shafts of sunlight, so too should he throw "rays" of air shadows —less conspicuous, of course, but evident none the less.

The shadow cast upon a surface by an object appears to cover it like a transparent

Two examples of luminosity in mist as described in Chapter 21. (pp. 95 ff.) Important to these effects are (a) a slightly subdued background, (b) lack of severe contrast, (c) and subtle gradations blending from the light sources into the field. Although the artist actually works with paints, he convincingly implies illumination. Other examples are shown on pages 94 and 95.

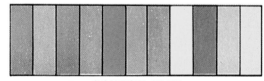

PALETTE XXIX

membrane. If the cast shadow moves, it does so not *in* the surface but *across* it. It changes the appearance of colors, but the eye senses that the colors are still normal—only modified by the film of shadow spread over them. (See C in Figure 31.)

Here is the secret: a delicate *transition* in brightness from normal color into shadow is what forms the perfect shadow! Your technique can be either opaque or transparent. The edge (penumbra) is all-important! Harden that edge with a severe line and your shadow may turn from a membrane to an opaque coating. This is true whether your technique is smooth like the Old Masters or broken like the Pointillists.

Cast shadows almost always show tinges of a hue that is complementary to the color of the light source. The shadows of summer are essentially blue (ultramarine). And here again, such shadows must be grayed. It is wholly erroneous to assume that bright complements give a more vivid effect than do grayed contrasts. They do not. Luminosity will be better achieved by following a sequence from purity to gray than one from a pure hue to its full opposite. When both sequences are followed, however—the full color in normal tone or highlight, and the grayed complement in shadow—the most striking and convincing of all beauty is attained.

The realistic painter should be conscious of the fact that the world is revealed by illumination, given form in highlight and shadow, and structure (or lack of it) in texture. All things have texture; even the open sky appears as a filmy free expanse of blue.

It is good practice to imply the inherent nature of things—the hardness of rock, the liquidness of water, the filminess of atmosphere, the laciness of foliage, the softness of cloth—or at least not forget that such qualities of texture exist. Interpretations do not have to be literal; human perception merely requires a hint.

Sir Joshua Reynolds wrote, "The drawing gives the form, the color its visible quality, and the light and shade its solidity." To this may be added, the general distribution of light and dark over a canvas (Law of Field Size or Proportion) establishes the character of the illumination, and the handling of texture assumes impressions of the inherent nature of things (modes of appearance).

Technique is a bother. It stands between the artist and his canvas. He may conjure beauty in his mind, but he can express it only through the manipulation of his medium and the skill of his eyes, hands and brain. Paintings unfortunately cannot be only thought; they must be executed.

The purpose of technique, thus is to give graphic expression to thought. However, it should be serf and not master; it should be accommodated to effect. In Perceptionism there are many short cuts to new visual experiences. With them art can do complex things in very simple ways.

Helmholtz, a great scientist, once wrote, "A study of the paintings of the great masters . . . is of great importance to physiological optics." Now it is known that a study of perception and physiological optics is great importance indeed to art. Both the objective scientist and the subjective painter would do well to make friends.

Experiments

Still life, and portrait pictorial effects should be attempted as experiments in highlight and shadow. The various points of this chapter should be studied and observed. The artist should appreciate the difference between a shadow (which should resemble the object-color in dim light) and a shade or tone itself (which may appear as a wholly different color form). The magic, of course, lies in technique, in soft edges, in the general relationship of tones throughout a composition.

He should also note that highlights appear opaque and tend to swing in hue toward the next higher adjacent on the color circle. Conjoined shadows tend to swing in hue toward the next lower adjacent. Cast shadows are generally complementary to the tint of the light source.

Figure 31. The appearance of shadows.

A. The conjoined shadow.

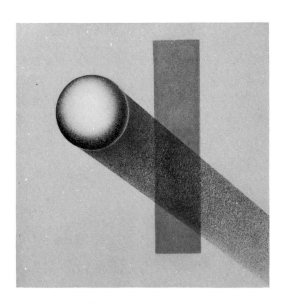

B. The air shadow.

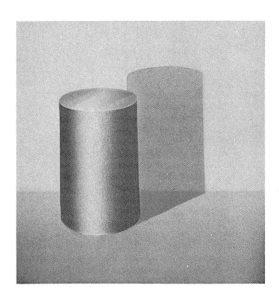

C. The cast shadow.

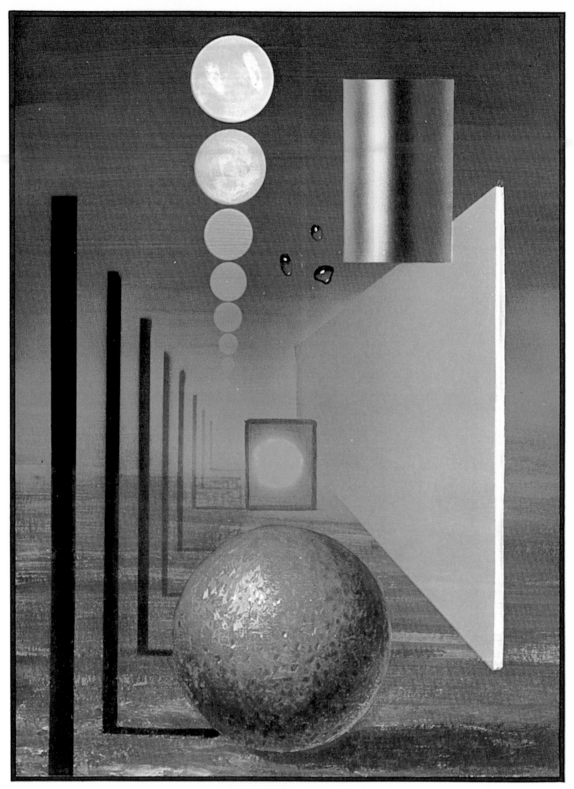

PALETTE XXX

24. Three-Dimensional Color

Color in full relief, or three dimensions, involves problems which are worthy of special attention. The architect, sculptor, ceramist, and industrial designer usually deal with structural objects or forms which are seen in space rather than on a flat background.

Three-dimensional color has occupied a good part of my interest and attention over many years. So much so that I have planned a companion volume to this one on color, form and space. The two books will make a practical pair, not only because they complement each other, but because they both are concerned with the phenomena of perception.

Much art that is limited to flat planes has attempted to create the illusion of roundness. As has been mentioned, the Old Masters were fascinated by the challenge. And in Chapter 22 (and the illustration on page

110), principles for the creation of three-dimensional effects have been reviewed.

Yet architects, sculptors and others who develop forms in space are not very likely to want people to think that such forms are flat. On the contrary, they prefer to glory in space and to make the very most of it.

Unfortunately, theories or principles of color in three dimensions are rare, and I know of no book exclusively devoted to them. What references there are in the literature of color usually restrict themselves to things best illustrated on the flat pages of a book.

Yet there is surely an art of color in three dimensions. *And there are expressions for color which demand plastic relief in space and which would be without the same meaning on a flat plane.* Here is a refreshing field of inquiry and one that could well mark out a new path and set up a new milestone in the progress of the color art.

At any rate, the idea is novel, sound and potentially useful in a world that seeks so ardently to revolutionize the physical and visual aspect of many things—buildings,

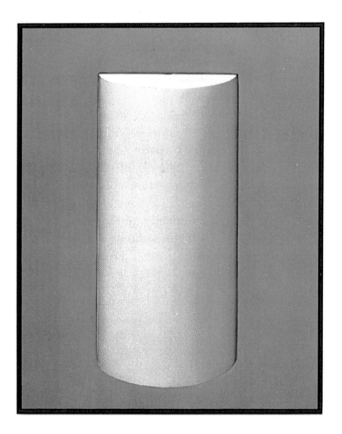

On the opposite page is an example of three-dimensionalism on a flat plane, as discussed in Chapter 22. Here is an effect of colored light applied to a plastic form, as taken up in Chapter 24. Both endeavor to give relief, solidity, a sense of space, to art forms. And both require that human perception takes part in the result.

industrial and consumer products, land and air vehicles, etc.

To begin, look at the small color illustration on page 111. A cylindrical block of wood has been painted with the three luminous colors of Palette XVIII described in Chapter 18 and illustrated (in a flat plane) on pages 82 and 83. The color reproduction (page 111) represents an actual photograph of the cylinder set upon a table in back of which lies a gray-blue panel. What was seen in three dimensions in the original setup has been fairly well caught in the photograph and the printed duplication of it. There is an important difference, however.

In the original, the on-the-spot viewer looked into space. He could determine size, distance, perspective through the convergence of his eyes, the accommodation of his lens mechanism, and his visual and mental judgment. He could further move from side to side, orient himself and establish a clear perception of what was before him.

The one unusual thing (and this shows up in the illustration on page 111) was the color effect. Somehow the viewer gained the impression that he was not looking at a *painted* cylinder, but at a chromatically *illuminated* one. He was seeing Perceptionism applied to a plastic form surrounded by space!

In structural things, man has been inclined to consider color a part of property of objects. These objects might be of different colors, but for the most part they have had to speak for themselves. There has been little challenge to perception. The illustration on page 111—which I am sure the reader will understand—uses color to mold the form. It builds an effect—an illusion—which forces the viewer to participate and makes him perceive an interplay of colored light where there actually is nothing but paint.

This may be trickery once again. But if it is so, it is art for the clear reason that it is ingenious and creative; it demonstrates that man can master natural phenomena and perform wonders on his own.

Now study the photographic reproductions on pages 114 and 115. All were taken in completely flat light, using actual wood models. The modes of appearance—dim light, mist, luster, iridescence—were arbitrarily and deliberately applied to the cylinders. A plain red cylinder is included for comparison. One sees fully controlled effects, which repeat, in three dimensions, several of the principles already given in this book.

The application of Perceptionism to architectural and three-dimensional forms holds many possibilities. In the phenomenon of aerial perspective (see Figure 32), it is noted that as colors and color values recede into distance, they tend to lose contrast and to "melt" into a medium-light gray. (Nature may sometimes tint the atmosphere rose, warm blue or purple.) In Figure 32 this effect is shown. However, in all three forms the black, gray, and white values were fixed in advance and the entire setup photographed in the same light—and obviously without distance or perspective introducing any mist or atmosphere whatsoever.

To my way of thinking, human perception of natural phenomena could be dramatically applied to plastic forms, particularly

to buildings and large architectural masses. Tall structures, for example, could have sharp contrast, pure color, white and black, fine detail and ornament at ground level (close to the observer). As upper elevations were reached, the colors, contrast and details could be softer—as nature herself softens them. The over-all effect would thus have perceptual elements and would constitute a kind of beauty which departed radically and unmistakably from the conventions of the past.

Likewise, the various principles and modes of appearance given in earlier chapters—luster, iridescence, luminosity, chromatic light, chromatic mist, color texture—could be applied to three-dimensional forms to give them a vitality and a certain mobility which, to my mind, would "loosen up"

the artist and free him from the static fixations of the past.

If I may compliment the gestalt psychologist, much of his research has been devoted to visual color phenomena and the perception of forms in space. Man lives in a three-dimensional world and is quite conscious of time and space.

In form itself (independent of color), man tends to see things in certain "instinctive" ways. He feels urged to simplify shapes and patterns, to demand good symmetry and balance. Slightly irregular forms will be seen as regular on short exposure or in after-images. He does not seem able to stand chaos or disturbed equilibrium. The eye, for example, will strive to center what it wishes to see, to keep it aligned with the forces of gravity. It is sensitive to certain

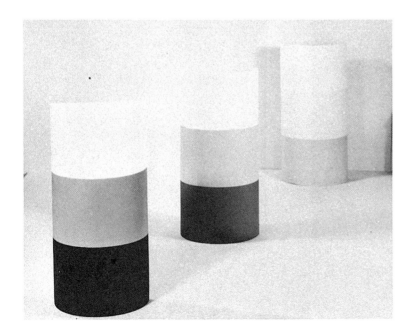

Figure 32. Aerial perspective. Colors and color values soften to a light or medium gray as they fall back into distance.

A normal red form.

A red form in dim light.

A pink form in mist.

A lustrous red form.

arrangements, proportions, intervals. That which is simple and direct will be more insistent than that which is complicated or indirect.

One point of great significance is that color is more immediate, as the psychologist says, than form in human perception. Man is impressed by it before he devotes his attention to anything else. Besides, no form—or surface, or space, or anything else—is colorless. Total darkness, for example, is not like black, but more like deep gray space. Yet much architectural tradition has assumed that forms, shapes and designs could be conceived in a geometric way, with color more or less abstracted or shunted aside. This is an impossibility. Nothing that is or can be seen is without color. In a broad sense, color comes before form, and the impression of it—together with the impression of illumination—comes ahead of any analysis one may make of shape or detail.

Color and form must be considered at the same time, for they are one and the same thing. Space is always filled—even with nothingness and even with the eyes closed. Man indeed lives in space (and time) and his whole life is spent in concentration upon that which fills space.

The world today is dynamic, not static. Sound values have been built around man as an active member of society. Art—including architecture—advances when it does not merely state visual facts as final in themselves, but when, through perception, it is open to interpretation so that man becomes a participant and not merely an outside bystander.

An iridescent pink form.

Perceptionism as related to three-dimensional form. All the effects shown were actually applied to the cylinders before they were photographed. Color does not have to be looked upon as an inherent part of material. It may be so manipulated and controlled as to engage human perception and serve new purposes in plastic art.

25. Fixed Palettes

In the early history of painting, fixed palettes were the rule. The craftsman, in fact, usually ground his own pigments, mixing various tones which were put up in jars and held in readiness for some creative work. The basic colors employed were extremely limited and frequently consisted of red, yellow and black. In painting, greens and violets were mostly implied, although such colors eventually were developed as time went on.

Renaissance artists fixed their palettes beforehand. Shadows were generally applied first, then the halftones, and finally the highlights. In many instances separate jars of colors were used for each of these applications, different fixed palettes being used for backgrounds and foregrounds. Aerial perspective was often handled this way, with one group of colors used for the foreground, another for the middle ground, and a third for the distance. In many respects, the receding and graying of colors as they fell into distance was in itself a wise observation of perception on the part of the Old Masters.

With the development of new and more brilliant pigments, and with less attention paid to intricate techniques, tones and shades were no longer mixed in advance but were formed as the artist needed them while he was actually executing his composition. This practice was current in the schools of Impressionism and Post-Impressionism and still prevails in modern times.

Today artists' pigments and most palettes are far from ideal. It is almost a first rule of harmony that the colors available should be "tuned." That is, a well balanced color circle should be on hand which contains hues neatly spaced apart and without wide gaps in some regions of the spectrum. Also, all colors should have the same approximate purity, otherwise the best control will not be possible.

Fixed palettes are nothing new to art. Some of the Impressionists used pure colors plus white only and created modifications and intermediates through visual mixtures in the *pointillistic* technique. They assumed —from the physicist—that all color was contained in the spectrum of light. Working with paints as lights, therefore, they believed they were adapting physical laws to artistic purposes. They were somewhat in error, however, for human vision has ideas of its own about color and color mixture and these, as has been mentioned, are often quite independent of the world of light energy.

Today, perception may be looked upon as a truer answer to creativeness in the use of color. It is far closer to beauty—and to the artist himself—because it is involved with human consciousness rather than with wave lengths of electromagnetic energy. Yet color is a progressive art. Chemistry has greatly expanded the availability of bright pigments, and this technical achievement should by all means be used. Yet colors— and palettes—need good order for the simple reason that visual perception itself is orderly.

Many an artist's palette is jumbled. Some

of his paints may be quite pure in chroma, while others may be dull. This can result in clumsiness—and delay—as he struggles to correct the situation *while actually engaged* in the creative art of painting. His palette ought to be balanced, his tools ought to be sharp, *before he starts*. He can then give himself to his visions and not be continually interrupted.

Where the artist makes an effort to carry out the various principles of Perceptionism given in this book (luster, iridescence, luminosity, chromatic light and chromatic mist), it is quite obvious that his palettes and color tones ought to be mixed in advance. They should be prepared and ready *before* a work of art is attempted. The struggle to mix individual tones one by one from a selection of pure hues—while undertaking a drawing—will not only slow up the creative operation but will probably result in an amateurish and clumsy result.

A pianist or violinist does not tune his instrument during the time that he is playing or composing. His keys and strings are previously set, and he can give full attention to the creative impulse without having to bother himself over mechanical adjustments.

Freedom of expression is one of the credos of modern art. The painter should be at liberty to interpret his feelings and moods. He should be unencumbered by technique and by time-consuming attention to irrelevant things. Consider the following two points:

— If the artist seeks unusual color effects but persists in working from a palette of basic pigments squeezed from tubes, he must constantly divert his attention to color mixture. Thus, his actions and his inspiration will be slowed down.

— However, if the colors and tones necessary to achieve his effect are mixed beforehand, he can work quickly and directly and give his entire attention to creative rather than mechanical tasks. Surely he will be able to produce superior works of art.

Eminent color effects almost demand fixed palettes. By separating the mixing process from the creative one, each in turn may be given full attention without conflict. The fixed palette will represent the tuning operation. This can be leisurely done, and simple experiments can be performed in anticipation of a final composition. Then when the artist goes about his work he can do so with purely emotional intensity—not having to concern himself with routine matters.

In preparing mixed palettes, only major colors need be mixed. If the work of art is to duplicate the effect of chromatic mist, for example, the artist should prepare a white, red, yellow, green, blue, purple, gray, and black—all as seen under the influence of one dominant color. In executing his drawing, he can use such key hues in combination, knowing in advance that any mixtures from them will be in proper relationship.

Also, the artist should always paint out a complete set of swatches and keep them filed away. Should he succeed in painting a really memorable work of art, he will then have a record of the color elements used to achieve it. In the course of time, he will build up a

useful collection of color effects which may come in handy in the future.

This is precisely what I have done in preparing the color plates in this book. I have further recorded my palettes in Munsell Notations for future reference. If my original swatches fade or get lost, I can always rematch them, using the scientific control of the Munsell system as a safekeeping vault.

In recent times the art of color in painting has been rather crude and elemental. This is to be explained by the fact that the artist has attempted to "clean house" and has sought to create a new school of expression from new beginnings. With new foundations set, real progress becomes possible and should be realized. A keen understanding of the visual and psychological aspects of color —of Perceptionism—should prove quite an incentive and should inspire confidence that a whole new world of expression lies open for conquest.

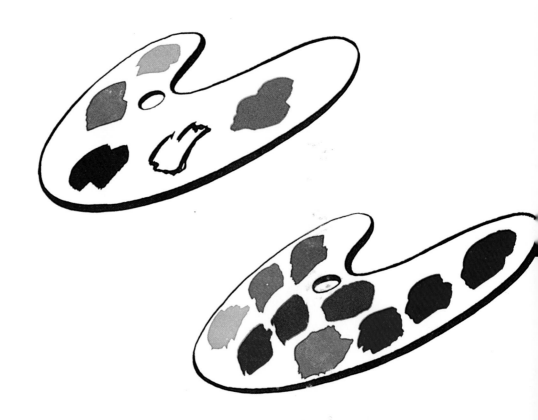

26. The Faber Birren Palettes

As has been previously mentioned, thirty illustrations reproduced in color in this book have been made from palettes developed by the author. While some of the drawings are realistic and others non-objective, all are meant to serve as color studies rather than finished works of art. The reader is asked to accept them as conscientious efforts to create a series of original color effects. Using the same basic principles, it is hoped that the competent artist will do far better.

The reader who would like to know what particular colors were selected to carry them out may refer to the Munsell Notations listed in the following pages for visual comparison.

The Munsell Notation affords a method for permanently recording color for today and for the future. The Munsell Book of Color (both matte and gloss collections) displays color samples which exemplify this notation system.

The color designations of these palettes have been visually estimated by the Munsell Color Company of Baltimore. While most of them, unfortunately, are not represented by actual samples in the Munsell Book of Color, they are fairly close. By studying the notations given and judging their relative position on the charts of the Munsell Book of Color, the artist should be able to make fair approximations. If he wants exact samples, the Munsell Color Company would be able to help him as a professional service.

Two points should be mentioned. First, the standards of any of the palettes may be intermixed at will and will result in a consistent over-all effect.

Second, where the palette has been based on normal color influence by colored illumination, the normal colors are indicated—but will not look the part, of course, in the fixed palette itself, having been radically changed by the colored illumination.

Well organized palettes are important to creative expression, for they establish effects in advance and enable the artist to work freely and rapidly and without unnecessary delays. Spontaneity may be lost if time-consuming color mixtures interrupt.

THE FABER BIRREN PALETTES

PALETTE I, ADJACENTS
Yellow-green: 9.26Y 6.5/8.6.
Green: 5G 5.1/8.5.
Blue: 6B 3.9/6.6.

PALETTE II, ADJACENTS
Pink: 3.8R 6.3/9.8.
Orange: 4YR 6.4/13.5.
Coral: 10R 6.3/12.
Red: 7R 4.2/14.

PALETTE III, ADJACENTS
Orchid: 3RP 5.7/11.3.
Purple: 5.3P 4.85/10.7.
Purple: 2.9P 3.7/8.3.
Violet: 1P 3.2/9.4.

PALETTE IV, COMPLEMENTS
Yellow-green: 10Y 8.3/9.1.
Green: 6GY 4.04/4.1.
Olive: 3.1GY 4.04/1.9.
Brown: 0.5YR 3.2/4.2.

PALETTE V, COMPLEMENTS
Pink: 7.5R 6.6/7.4.
Pink: 6.5R 5.6/7.3.
Brown: 8R 3.4/7.
Aqua: 5B 6.7/5.9.
Turquoise: 6B 6/6.8.
Turquoise: 5B 5/8.

PALETTE VI, SPLIT-COMPLEMENTS
Yellow: 7Y 9/5.
Yellow: 4.5Y 8.9/13.5.
Violet: 10PB 5/10.1.
Violet: 10PB 3.3/11.5.
Purple: 7.5P 5.2/8.3.
Purple: 8P 5/14.

PALETTE VII, BALANCED TRIAD
Pink: 3.5R 6.4/9.8.
Red: 5R 5.2/11.3.
Yellow: 7Y 9/5.5.
Yellow: 6Y 8.5/10.5.
Aqua: 3.5B 7/5.
Turquoise: 3.5B 5.8/6.2.
Black.

PALETTE VIII, BALANCED TRIAD
Green: 1.5G 7.5/6.
Green: 1.5G 7/7.
Green: 1.5G 6.5/8.
Green: 2.6G 3.5/4.5.
Peach: 7YR 8/6.
Orange: 3YR 7.3/10.
Orchid: 6P 7/6.4.
Purple: 5.3P 5.4/11.

PALETTE IX, BALANCED TETRAD
Pink: 3.5R 6.3/9.8.
Red: 5R 5.2/11.3.
Yellow: 5.5Y 8.9/4.5.
Yellow: 5Y 8.5/10.5.
Green: 5G 7.3/5.2.
Green: 5.3G 4.8/6.4.
Blue: 4PB 7.5/6.
Blue: 6PB 5.3/10.
Gray: N 6.5/.

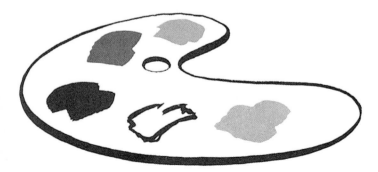

PALETTE X, RED ILLUMINATION
Red under red illumination: 7.5R 5/13.
Yellow under red illumination: 0.2YR 5.8/13.
Green under red illumination: 4YR 5.3/8.5.
Blue under red illumination: 10R 5.05/8.
Purple under red illumination: 5.5R 4.5/7.5.
White under red illumination: 6.2R 5.2/10.
Gray under red illumination: 7.5R 3.8/7.
Black under red illumination: 7.5R 2.5/4.

PALETTE XI, YELLOW ILLUMINATION
Red under yellow illumination: 7YR 6/12.
Yellow under yellow illumination:
 10YR 7.3/12.6.
Green under yellow illumination: 7.5Y 6.1/8.2.
Blue under yellow illumination: 2.5GY 5.5/6.5.
Light gray under yellow illumination:
 10YR 6.5/5.
Black under yellow illumination: 10YR 4/3.
White under yellow illumination: 5.5Y 7.8/12.

PALETTE XII, GREEN ILLUMINATION
Yellow under green illumination: 2.5G 6.5/5.5.
Yellow-orange under green illumination:
 5GY 6/5.
Orange under green illumination: 7.5Y 5.2/3.5.
Red-orange under green illumination:
 8YR 4.5/3.5.
Red under green illumination: 2.5YR 3/2.5.
Light green under green illumination: 1G 5/6.
Green under green illumination: 2.5G 4/5.5.
Gray under green illumination: 1G 2.5/3.
Black under green illumination: 5BG 2/1.

PALETTE XIII, BLUE ILLUMINATION
Red under blue illumination: 2.5YR 3/3.
Orange under blue illumination: 8Y 5.3/4.
Yellow under blue illumination: 6PB 4.7/10.
Green under blue illumination: 3.5B 3.5/4.2.
Purple under blue illumination: 7.5PB 3.2/12.
White under blue illumination: 6PB 6.3/7.
Black under blue illumination: 1P 2.9/9.

PALETTE XIV, STUDY IN SILK LUSTER
Red scale: 8R 5.05/15; 6R 4.1/13; 5R 2.8/4.
Orange scale: 2.5YR 6.8/14; 1YR 4.8/8;
 1YR 3.2/4.
Yellow scale: 4.5Y 8.5/13; 5.5Y 6.1/7; 5Y 4.5/4.
Green scale: 7GY 7.1/10.5; 9GY 5.3/7;
 2.5G 3.8/5.
Blue scale: 5.5B 5.5/8.5; 5B 3.7/5; 5B 2.5/2.
Purple scale: 10P 4.1/11.5; 7.5P 3/5; 7.5P 2/4.
Black.

PALETTE XV, STUDY IN IRIDESCENCE (Page 74)
Red Scale: 7.5R 7/10; 7.5R 6/10.
Orange Scale: 7.5R 7/6; 10R 6/4.
Green Scale: 10GY 7/6; 10GY 6/4.
Violet Scale: 10P 7/6; 5RP 6/4.
Purple Scale: 2.5RP 7/10; 5RP 6/8; 5RP 5/4.

PALETTE XVI, STUDY IN IRIDESCENCE
Beige scale: 5YR 4/1; 7.5YR 6.2/2; 10YR 7/2.
Purple scale: 3R 5/4; 2.5RP 6.7/7.
Blue scale: 10G 5/1; 3B 6/5.7.
Green scale: 4GY 5/1.5; 1G 6.8/6.
Yellow scale: 6.5YR 6/4.5; 10YR 7.4/7.5.
Pink scale: 10R 4.7/4; 6R 6.3/8.

PALETTE XVII, EFFECT OF RED AND BLUE LIGHT
Red: 5R 6.4/12.
Transition tone: 5RP 6.2/3.
Blue: 7.5B 6/8.
Background blue, medium: 9B 4.3/2.5.
Background blue, deep: 1PB 2.5/1.

PALETTE XVIII, STUDY IN LUMINOSITY
Yellow-green: 1GY 7.6/10.
Yellow: 5.5Y 7.5/11.
Dull orange: 2.5Y 6/8.
Greenish brown: 4Y 4.2/4.5.

PALETTE XIX, YELLOW-GREEN ILLUMINATION
Red under yellow-green illumination: 7.5YR 6/9.
Orange under yellow-green illumination:
 1.5Y 5.8/7.
Yellow under yellow-green illumination:
 3GY 6/8.
Green under yellow-green illumination:
 2.5GY 5.7/7.
Blue under yellow-green illumination: 7.5Y 5/5.
Purple under yellow-green illumination: 4Y 6/7.
White under yellow-green illumination:
 1GY 7.5/9.
Gray under yellow-green illumination:
 1.5GY 3.8/3.
Black under yellow-green illumination:
 2.5GY 2.5/3.

PALETTE XX, STUDY IN BLUE CHROMATIC MIST
Red under blue mist: 2.5G 4.7/1.7.
Yellow under blue mist: 7G 5.1/6.
Green under blue mist: 2B 4.1/5.
Purple under blue mist: 5PB 5/6.
White under blue mist: 5BG 6/6.5.
Black under blue mist: 10BG 3/4.
Iridescent green: 8.5GY 7/5.3.
Iridescent lavender: 2RP 6.5/4.6.
Iridescent pink: 2.5YR 7.5/5.

PALETTE XXI, LUMINOSITY IN BLUE MIST
Black under blue mist: 1.5B 4/5.
Gray under blue mist: 7.5BG 6.5/4.8.
White under blue mist: 7.5BG 7.2/4.8.
Luminous purple: 5RP 7/5.
Purple under blue mist: 5.5PB 5/4.5.
Luminous green: 9GY 7.3/5.5.
Green under blue mist: 7.5G 5.5/4.5.
Luminous yellow: 10YR 8/6.5.
Yellow under blue mist: 10GY 5.1/2.2.
Luminous pink: 6.2R 7/6.5.
Pink under blue mist: 7.5PB 5/1.8.

PALETTE XXII, LUMINOSITY IN PINK MIST
Black under pink mist: 5RP 4/3.
Gray under pink mist: 5R 6/5.
White under pink mist: 4.5R 7/5.
Luminous blue: 6.5B 7.2/5.5.
Blue under pink mist: 2.5P 5.4/2.
Luminous yellow: 4GY 8/5.
Yellow under pink mist: 8.5YR 6/4.5.

PALETTE XXIII, MODES OF APPEARANCE OF
 COLOR (Page 98)
Red: 7.5R Max.
Yellow: 5Y 8/14.
Green: 1.25G 6/12.
Blue: 2.5PB 4/10.
Purple: 10P 4/12.
White.
Black.

PALETTE XXIV, STUDY IN TRANSPARENCY
Deep violet: 8PB 2.2/7.5.
Blue scale: 2PB 5.5/7; 2.5PB 4/6.5; 2PB 3.3/5.
Green scale: 7.5GY 5.6/6.5; 8GY 4.5/5;
 9GY 4/3.5.
Red scale: 7R 4.8/14; 6.5R 4/10; 5R 3.2/7.
Background beige scale: 1.5YR 8/2.3;
 2.5YR 6.3/2; 2.5YR 4.9/2.
Deep green: 5.5BG 3.1/6.

PALETTE XXV, LUMINOUS EFFECT
Blue: 7PB 6/11.
Violet: 7P 4.7/5.5.

PALETTE XXVI, LUMINOUS EFFECT
Yellow-green: 0.5GY 7.6/8.
Golden tan: 8YR 6.3/8.

PALETTE XXVII, LUMINOUS EFFECT
Purple: 5RP 5/5.7.
Pink: 3.5R 6.5/9.
Purple (star): 7.5P 5.7/6.
Blue (star): 7.5PB 6/8.
Turquoise (star): 7.5B 6.5/7.

PALETTE XXVIII, LUMINOSITY IN VIOLET MIST
Black under violet mist: 5.5P 3.9/4.2.
Gray under violet mist: 1.5RP 6.5/5.
White under violet mist: 2.5RP 7.2/5.
Luminous blue: 2.5B 6.8/5.
Blue under violet mist: 5.5PB 5/6.
Luminous green: 9GY 7.2/3.5.
Green under violet mist: 5B 5.3/1.
Luminous yellow: 3.5Y 8.2/5.
Yellow under violet mist: 3.8YR 5.3/3.5.
Luminous pink: 7.5R 7/5.8.
Pink under violet mist: 1.5R 5/8.5.

PALETTE XXIX, LUMINOSITY IN GREEN MIST
Pink under green mist: 5YR 5.4/5.
Luminous pink: 5R 7/7.
Purple under green mist: 2YR 5/3.
Luminous purple: 1.5RP 7/5.5.
Blue under green mist: 5G 4.8/3.
Luminous blue: 5PB 7.2/5.8.
Yellow under green mist: 2Y 5.8/5.5.
Luminous yellow: 10YR 8.3/6.5.
Black under green mist: 8.5GY 4.2/3.
Gray under green mist: 2.5GY 6.8/4.
White under green mist: 2GY 7.9/5.7.

PALETTE XXX, THREE-DIMENSIONAL EFFECT
 (Page 110)
Red: 10R 5/16.
Yellow: 5Y 8.5/14.
Green: 10GY 6/12.
Blue: 5PB 4/12.
White.
Black.

Bibliography

Birren, Faber, *Color Psychology and Color Therapy*, McGraw-Hill Book Co., New York, 1950.

Birren, Faber, *Monument to Color*, McFarlane, Ward, McFarlane, New York, 1938.

Birren, Faber, *New Horizons in Color*, Reinhold Publishing Corp., New York, 1955.

Birren, Faber, *The Story of Color*, Crimson Press, Westport, Conn., 1941.

Boring, Edwin G., *Sensation and Perception in the History of Experimental Psychology*, Appleton-Century-Crofts, New York, 1942.

Chevreul, M. E., *Principles of Harmony and Contrast of Colours*, Bell & Daldy, London, 1870.

Evans, Ralph M., *An Introduction to Color*, John Wiley & Sons, New York, 1948.

Goldstein, Kurt, *The Organism*, American Book Co., New York, 1939.

Graves, Maitland, *The Art of Color and Design*, McGraw-Hill Book Co., New York, 1941.

Graves, Maitland, *Color Fundamentals*, McGraw-Hill Book Co., New York, 1952.

Guptill, Arthur L., *Color in Sketching and Rendering*, Reinhold Publishing Corporation, New York, 1935.

Hiler, Hilair, *Color Harmony and Pigments*, Favor Ruhl & Co., Chicago, 1942.

Hiler, Hilair, *Notes on the Technique of Painting*, Oxford University Press, New York, 1934.

Jacobson, Egbert, *Basic Color*, Paul Theobald, Chicago, 1948.

Judd, Deane B., *Color in Business, Science and Industry*, John Wiley & Sons, New York, 1952.

Katz, David, *The World of Color*, Kegan Paul, Trench, Trubner & Co., London, 1935.

Klein, Adrian Bernard, *Colour-Music*, Lockwood & Son, London, 1930.

Luckiesh, M., *Color and its Applications*, D. Van Nostrand & Co., New York, 1921.

Mayer, Ralph, *The Artist's Handbook of Materials and Techniques*, Viking Press, Inc., New York, 1940.

Munsell, Albert H., *A Color Notation*, Munsell Color Co., Baltimore, 1936.

Ostwald, Wilhelm, *Colour Science, Parts I and II*, Winsor & Newton, London, 1933.

Sargent, Walter, *The Enjoyment and Use of Color*, Charles Scribner's Sons, New York, 1923.

Werner, Heinz, *Comparative Psychology of Mental Development*, Follett Publishing Co., Chicago, 1948.

Index

Italicized page numbers refer to color illustrations.